WEST HIGHLAND PIERS

Alistair Deayton

AMBERLEY

First published 2012

Amberley Publishing
The Hill, Stroud
Gloucestershire, GL5 4EP

www.amberley-books.com

British Library Cataloguing in Publication Data.
A catalogue record for this book is available from the British Library.

ISBN 978 1 4456 0097 0

Typeset in 10pt on 12pt Sabon.
Typesetting and Origination by Amberley Publishing.
Printed in the UK.

Introduction

The piers covered in this volume are the mainland piers of the West Highlands, covering an area from the Mull of Kintyre north to Cape Wrath and round to Scrabster, which saw occasional calls by MacBrayne steamers, mainly conveying fishermen from Lewis. Over the years since the introduction of steam navigation, there have been many piers, ferry calls and car ferry slipways used, although the building and surfacing of roads in the first half of the twentieth century and consequent withdrawal of cargo steamer services has led to many being abandoned.

The traditional wooden piers, so prevalent in the Firth of Clyde (see the author's *Clyde Coast Piers*, Amberley 2010), were not so common in the West Highlands and many stone piers were used; steamers also called at general commercial ports such as Lochinver, and at a number of fishing piers, some built in an expansionist era of the fishing trade in the late eighteenth century by the British Fisheries Society when towns such as Ullapool were founded, as were some small settlements.

The expansion of the railway network led to the enhancement of services from Oban in 1880, and the establishment of piers at Mallaig in 1901 and Strome Ferry in 1870, itself replaced by Kyle of Lochalsh in 1897.

The development of car ferry services led to the building of a number of car ferry slipways, while the building of bridges in the second half of the twentieth century has meant that a number of these crossings were abandoned, such as those at Dornie, Ballachulish and Kylesku. The introduction of the roll-on roll-off car ferries on the longer routes led to many piers being transformed by the building of linkspans to access such ferries at and state of the tide.

The entire area covered in this volume relied on vast knowledge, a lot passed on through several generations of the same families. The number of steamers lost by grounding throughout the era before radar and GPS were introduced can be explained by this. The masters of the twenty-first-century ships continue this great tradition.

This volume also covers piers on the inland lochs of the West Highlands: Loch Eck, Loch Awe, Loch Shiel and Loch Maree, also the sea loch Loch Etive, which has always had its own service because the tidal race at the Falls of Lora has, in the main, precluded through services into or out of the loch.

The illustrations in this volume show most of the piers and slipways over the years, the vast majority served by the steamers and motor vessels of David MacBrayne Ltd, since 1973 Caledonian MacBrayne. (For more details of these steamers see *A MacBrayne Album* by the author and Iain Quinn, Amberley 2009).

Many of the ferry calls and smaller piers predate the era of popular photography and some were very remote and difficult to get to. In this respect it is essential to pay tribute to the late Jim Aikman Smith, a former secretary of the West Highland Steamer Club, whose indefatigable efforts in photographing unusual vessels at unusual ports of call have been unsurpassed.

Acknowledgements

My thanks are due as always to Iain Quinn for help with the text and for the supply of some photographs. Thanks are also due to several giants no longer with us: C. L. D. Duckworth and Graham E. Langmuir for gathering the historical material on steamer service in the West Highlands in *West Highland Steamers*, originally published in 1935; Jim Aikman Smith for his mammoth task in photographing ships and ferries from the 1960s until his untimely death in 1995; and Hamish Stewart in recording a more recent era.

Thanks are also due to Ian Somerville, Fraser MacHaffie, Peter Reid, Edward Quinn, Neil King, Fraser Pettigrew, Robert Beale and the University of British Columbia, Botanical Garden Archives, John Davidson Collection.

Chapter 1

Mainland Piers of Argyllshire

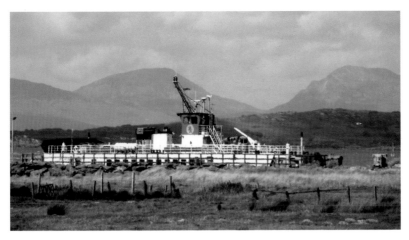

The slipway at Tayinloan has been used for Caledonian MacBrayne's ferry service to Gigha since 11 November 1980. *Loch Ranza*, the regular ferry on the route, is seen there on 31 May 2011, with the Paps of Jura in the background.

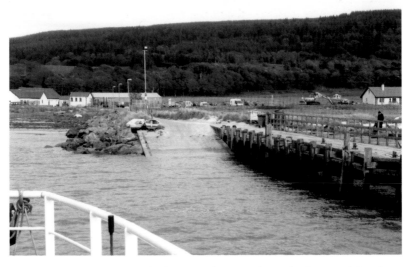

The slipway at Tayinloan on the same day seen from the ferry arriving from Gigha and showing the adjacent pier, which gives the ferry some protection when berthed there overnight.

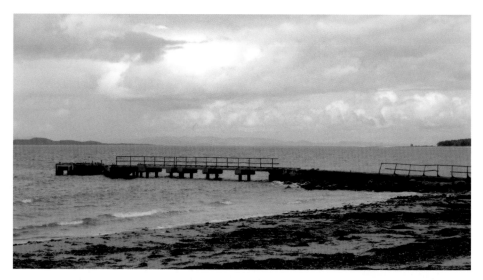

The basic jetty at Tayinloan, built in the late 1960s and used for the passenger ferry service to Gigha prior to the introduction of the car ferry service, which was maintained by a small boat and whose history went back at least to the 1790s, being mentioned in the 1793 Statistical Account. Major improvement works at Tayinloan over the winter of 2011/12 will mean the removal of this pier as part of major works to prevent sand being deposited at the bottom of the slipway. Between 70,000 and 80,000 tonnes of sand will be moved from the beach south of the pier to this area to the north, an open section or bridge will be created in the causeway leading to the slipway and the slipway will be widened.

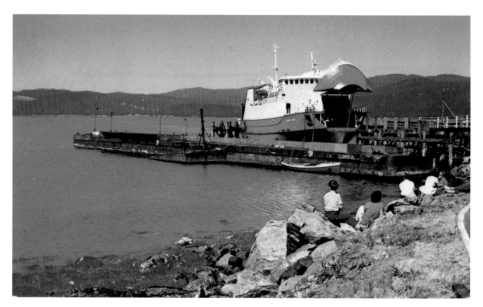

The ferry terminal at Kennacraig was opened on 7 April 1968 for the pioneer ro-ro service to Islay introduced by Western Ferries, initially with *Sound of Islay*, and from the following year with *Sound of Jura*, illustrated. The barge to the left was used as a breakwater, then sank and was not removed until alterations prior to the arrival of the new *Finlaggan* in 2010/2011.

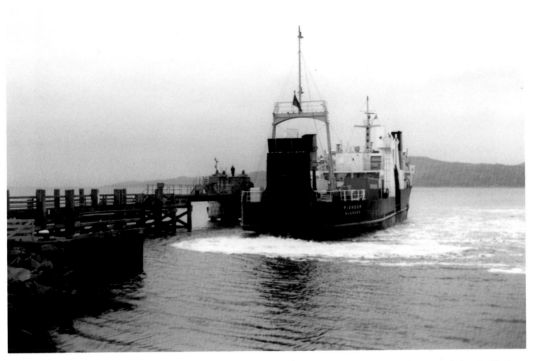

On 25 June 1978, Caledonian MacBrayne transferred their Islay service from West Loch Tarbert to Kennacraig. *Pioneer* is seen here off the linkspan.

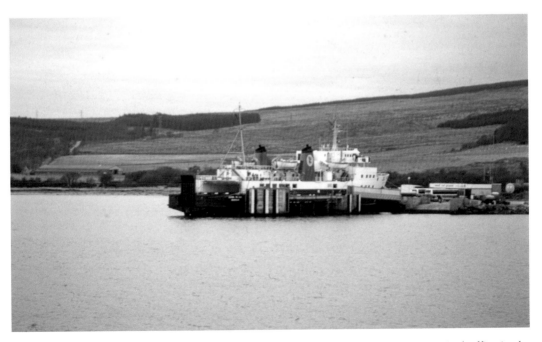

Isle of Arran at Kennacraig in 1996, showing the Caledonian MacBrayne terminal office in the background

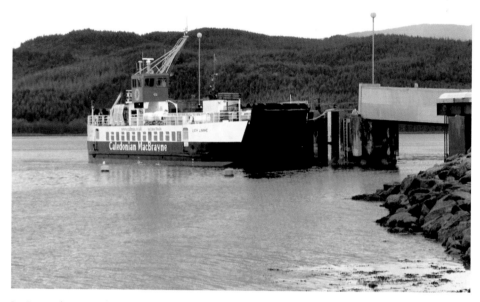

In December 2006, Gigha sailings were diverted to Kennacraig because of a build-up of weed and stones on the slipway at Tayinloan following storms. *Loch Linnhe* assisted the regular ferry *Loch Ranza* in that period, and is seen here at Kennacraig on 9 December. The service had initially run from Kennacraig from its introduction on February 15 1979 until the opening of the slipway at Tayinloan on November 11 1980.

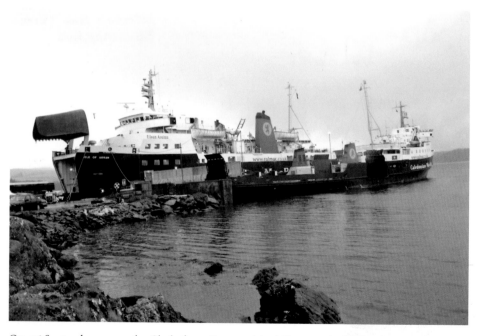

On 16 September 2007, the Clyde ferry *Saturn* visited Kennacraig for berthing trials, and is seen here with the regular Islay ferry at that time, *Isle of Arran*.

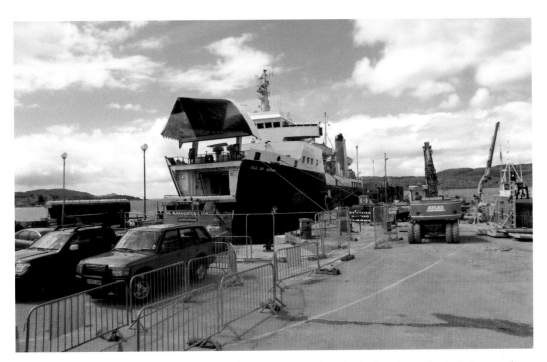

Alterations had to be made to the infrastructure at Kennacraig for the arrival of the new ferry, *Finlaggan*. *Isle of Arran* is seen there on 30 May 2011 at the south berth, with the north one surrounded by pier works.

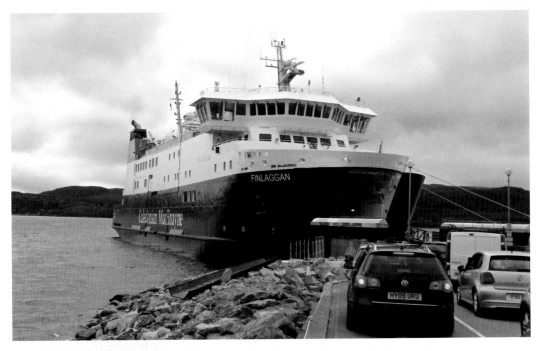

The new Islay ferry *Finlaggan* at the south linkspan at Kennacraig on 14 July 2011.

A new berthing dolphin was built in spring 2011 at Kennacraig and the berths were rebuilt, the south having been completed by the date of this photo, with work still underway on the north one, which had previously just been a berth with no linkspan because of the small tidal range there.

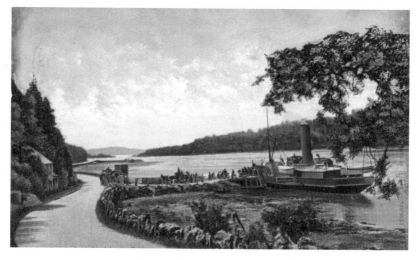

The pier at West Loch Tarbert dates back to the early days of steam navigation, with services from there to Islay and Jura starting in 1826. MacBrayne's veteran *Glencoe* of 1846 is seen there in a postcard view posted in 1908, although dating from a few years earlier, as the steamer was on the Islay service from 1890 until 1905.

In the 1880s there were two connecting ferries in West Loch Tarbert, one at Dunmore House and one at Ardpatrick House on the Knapdale shore, the latter also serving Clachan on the Kintyre shore. These were ancient cross-loch ferries, operated by rowing boats since the 1600s, from Dunmore to Kilchamaig, and from Ardpatrick to near Clachan. The latter one lasted probably till the early 1950s, but the other had ceased by the beginning of the twentieth century.

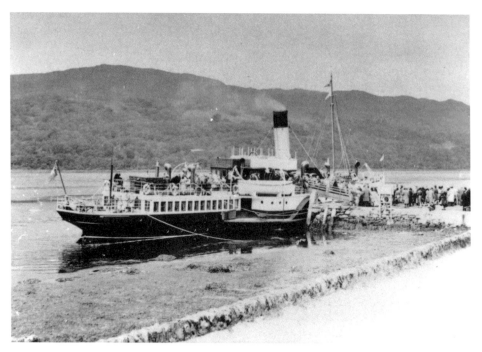

Crowds boarding the paddle steamer *Pioneer* at West Loch Tarbert. She served the Islay route from building in 1905 until 1940, when she was replaced by the motor vessel *Lochiel*.

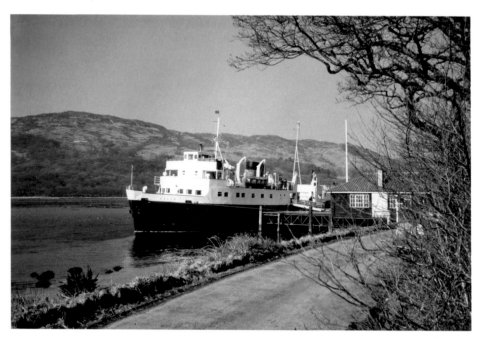

In 1970, the Clyde hoist-loading car ferry *Arran* was transferred to the Islay service to replace *Lochiel* and to provide a hoist-loading car ferry service, which she did until replaced by *Pioneer* in 1974.

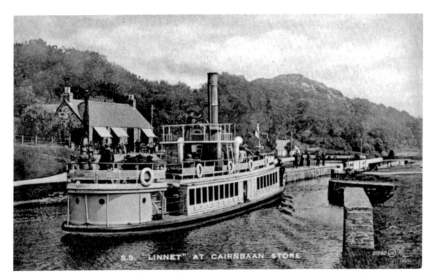

The eastern end of the Crinan Canal at Ardrishaig has been covered already in *Clyde Coast Piers*, but, around half way along the canal at Cairnbaan, while the steamer was negotiating the locks, passengers on *Linnet*, pictured here, could disembark for refreshments. There was a store here, and a hotel, which, disappointingly for many travellers, was a temperance establishment.

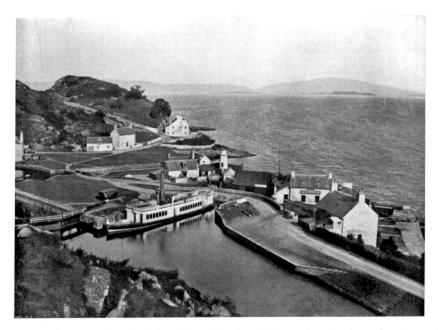

Crinan is at the seaward end of the Crinan Canal, and is seen here in the early 1890s with MacBrayne's canal steamer *Linnet* at her berth, above the lock leading down to the basin. To the far right can be seen the pier where passengers would join the steamer for Oban and Fort William. The Crinan Hotel was rebuilt after this to its present form. South of Crinan is the village of Tayvallich, which was listed as a calling point of the cargo steamer *Lochshiel* in a 1933 handbill.

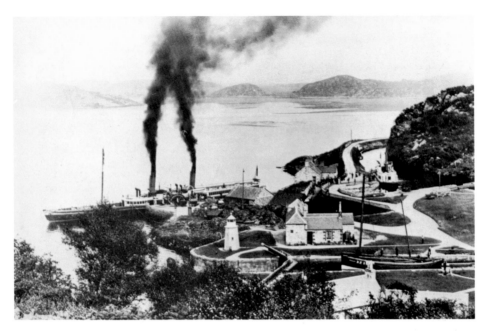

Chevalier is ready to depart for Oban, Fort William and Corpach here, with passengers making their way down from *Linnet* moored on the canal. This connection lasted from 1866, when both steamers were built, to 1928, when both services were replaced by a bus service from Ardrishaig to Oban, although *Chevalier* had been replaced by the *Mountaineer* of 1910 on the Oban service in the 1920s.

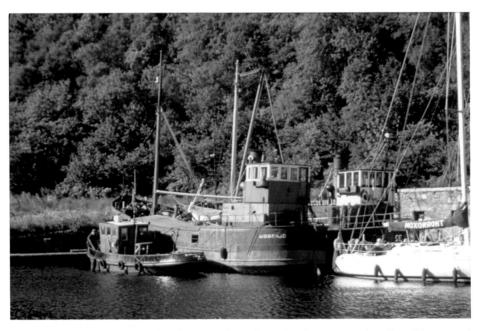

In recent years Crinan basin has been used as a base for the preserved puffers *VIC 32* and *Auld Reekie*, formerly *VIC 27*, which are seen berthed side by side in 1994.

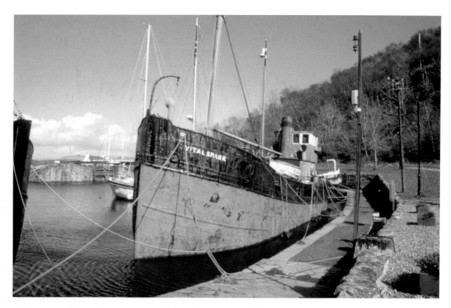

Auld Reekie, unofficially and temporarily renamed *Vital Spark* in honour of the puffer in Neil Munro's *Para Handy Tales*, is seen in Crinan Basin in 2006. She has had little luck, with many years spent laid up, then an abortive sale to a maritime museum in Inveraray and a tow through to Ardrishaig, and a recent purchase for preservation, a return to Crinan under tow and restoration on a slipway at Crinan Boatyard, round beyond the hotel. The latest news at the time of writing is that money has run out to complete the rebuild.

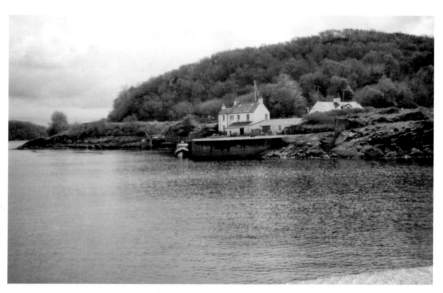

Crinan Pier on 1 May 2010 from *Rover*, which had made the first passenger call there for almost twenty-five years. After the Oban sailings ceased in 1928 there were occasional calls on excursions from Oban in the 1930s, and one advertised to land by *Lochmor* on 27 August 1948, although it is uncertain if this took place. *Waverley* made a handful of calls from 1985 onwards, but poor berthing facilities have made these impossible since then.

Chapter 2

Piers of Oban and the surrounding area

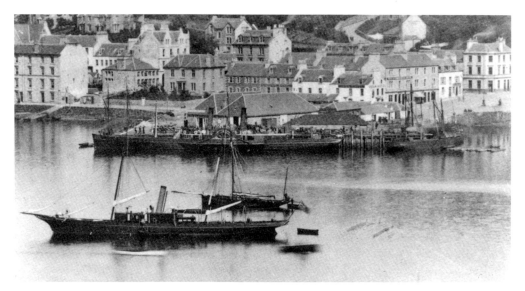

Oban North Pier was built prior to 1846 on the wrecks of old ships and boats and was traditionally the departure point for excursion steamers. *Pioneer* is seen there between 1874 and 1893 with a steam yacht in the foreground.

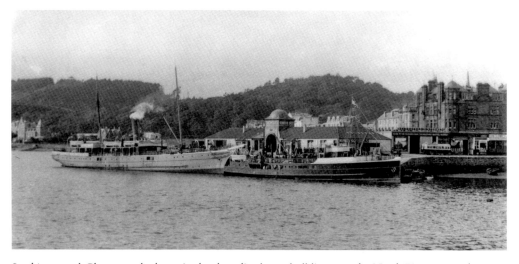

Lochinvar and *Claymore*, the latter in the short-lived grey hull livery, at the North Pier on 12 July 1929.

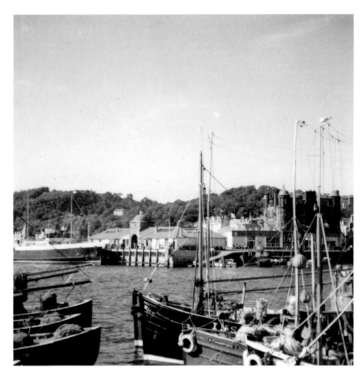

Lochnevis at the North Pier in the early 1960s.

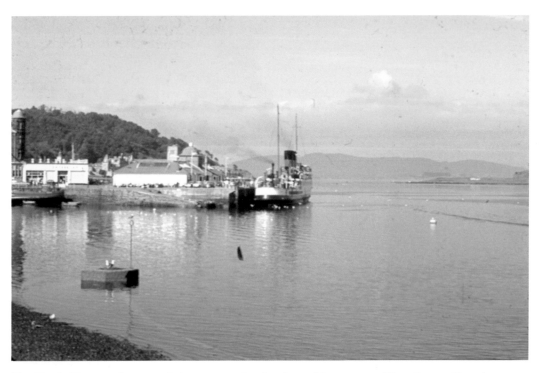

The North Pier was the normal departure point for the turbine steamer *King George V* on her Sacred Isle Cruise to Staffa and Iona.

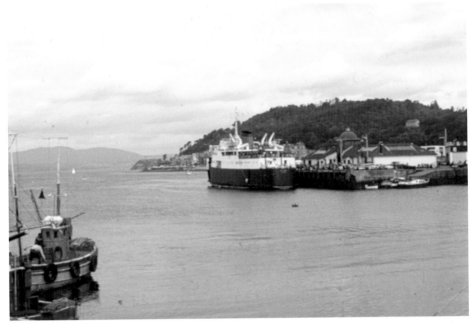

From 1964 until the opening of the linkspan in 1976, the hoist-loading car ferry *Columba* and her successors sailed from the North Pier to Craignure and Lochaline.

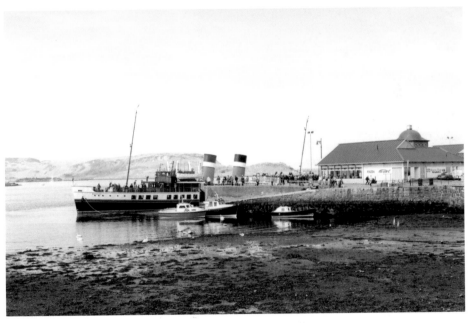

In 2003 the North Pier buildings, which dated from 1927, were replaced by a couple of glass-walled restaurants, although the central archway and tower was retained. *Waverley* is seen there after these alterations with the small excursion boats *Maid of the Firth* and *Kingfisher* moored in her lee.

From 1964 until 1975 the outer face of the North Pier was used by *Loch Toscaig* on the Lismore run.

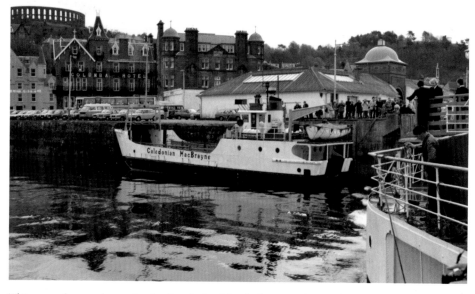

This was also used as a lay-by berth for Island-class car ferries, like *Coll*, seen here from the departing *Waverley*.

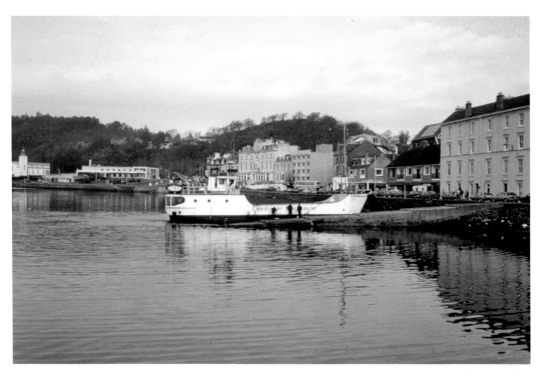

Island-class car ferry *Eigg* is seen here in 1990 unusually berthed at the Corran Esplanade Slipway used by the small excursion vessels.

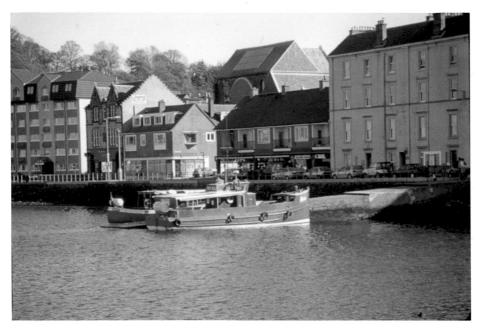

Two such excursion vessels, the outermost of which is *Duchess*, at the slip in 1999. These sail to Duart Castle on Mull, to Kerrera and offer seal-watching trips.

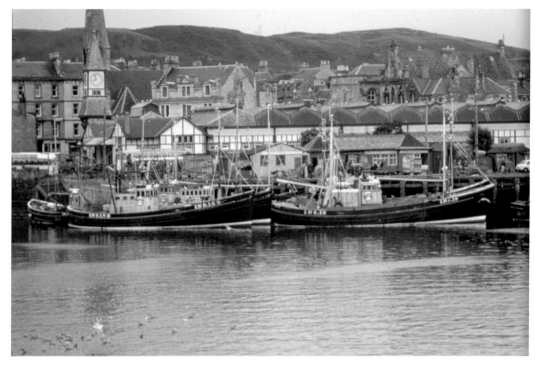

The Railway Pier was adjacent to the station, with both having been built on reclaimed land, although for many years the portion adjoining the station was occupied by fishing boats, as in this view from 1969 showing the old station buildings and clock tower in the background.

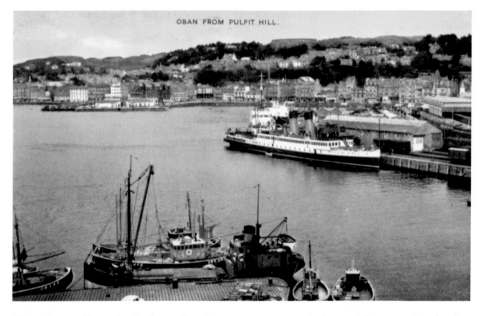

King George V at the Railway Pier in a 1950s postcard view, with a couple of other MacBrayne vessels behind her.

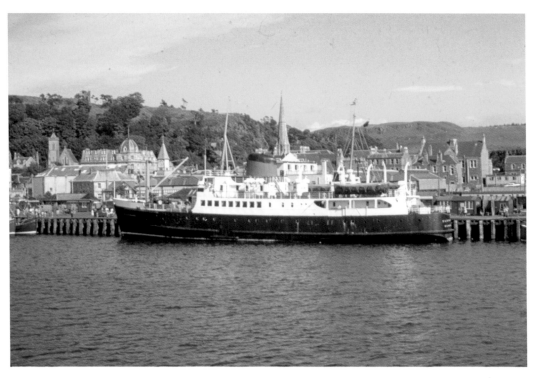

The Inner Islands mail 'steamer' *Claymore* at her berth at the Railway Pier in 1971.

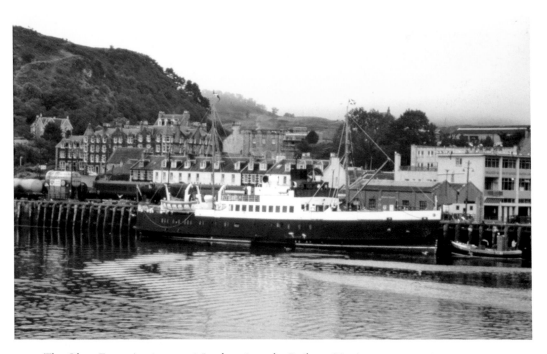

The Oban Excursion 'steamer' *Lochnevis* at the Railway Pier in summer 1969.

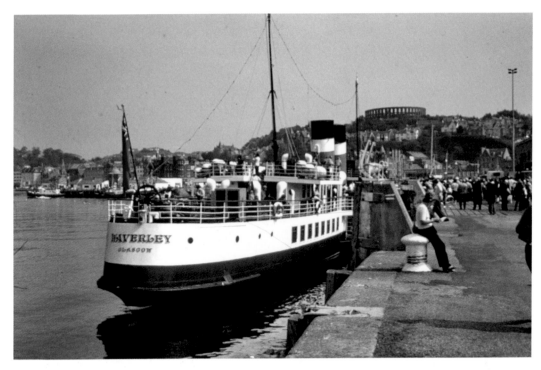

1984 was the only year that *Waverley* berthed at the Railway Pier and not the North Pier. This was for a unique excursion to Staffa.

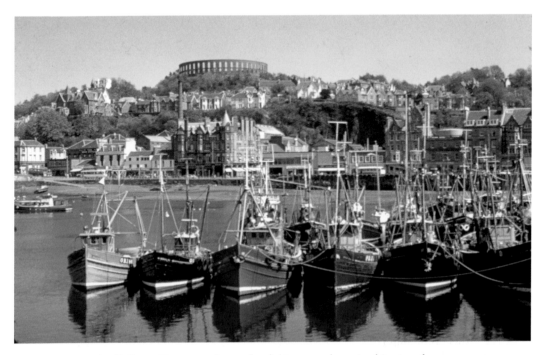

For many years the Railway Pier was a haven for fishing vessels, as in this view from 1973.

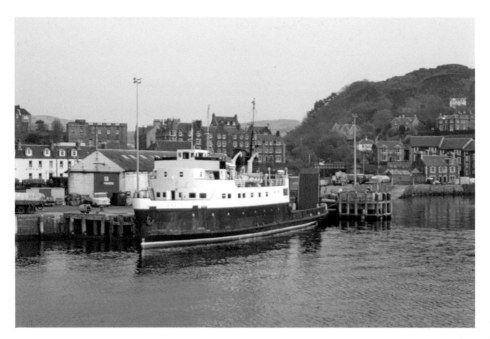

In 1976 a linkspan was built at the southernmost extremity of the Railway Pier for a roll-on/roll-off ferry service to Craignure, and the former Clyde ferry *Arran*, converted to a stern-loader, is seen there in 1978.

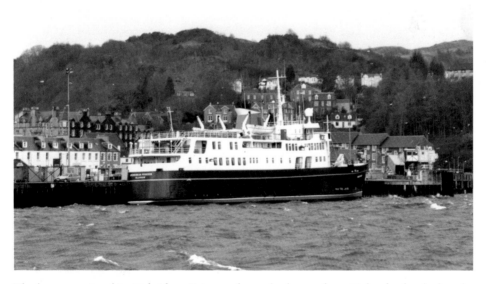

The luxury cruise ship *Hebridean Princess*, formerly the car ferry *Columba*, berthed at the Railway Pier.

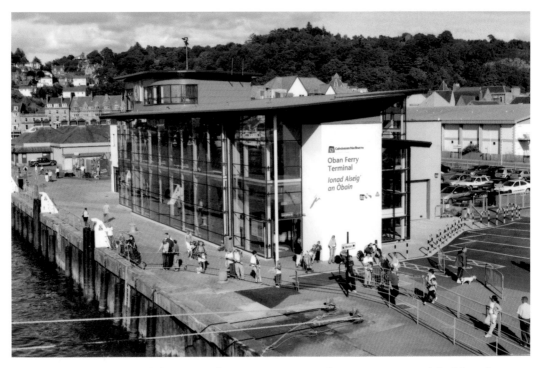

In the early years of the twenty-first century a new three-storey terminal building for Caledonian MacBrayne was erected at the Railway Pier.

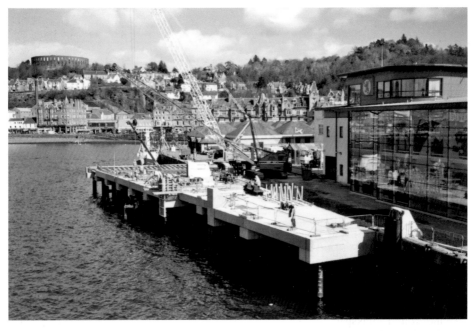

2006 saw the building of a second linkspan to enable ferries for Mull and for Coll and Tiree or Barra and Lochboisdale to berth and load simultaneously.

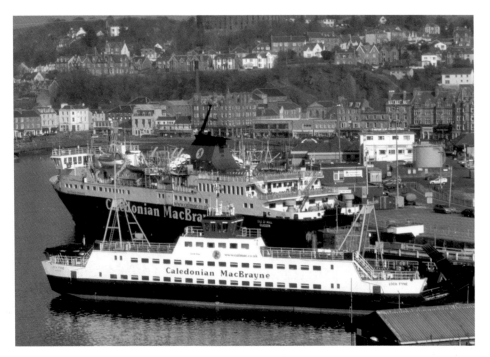

Isle of Mull at the original linkspan, while *Loch Fyne* has departed the ferry ramp on a special sailing. In the background to the right is the new station, a much more basic affair then the original, while to the left, the new building on the North Pier is under construction, with scaffolding across the front.

Round from the linkspan is a slipway used by the ferry to Lismore since 1974. *Eigg*, which has served the route for most of that period, is seen there *c.* 1999 subsequent to the raising of her wheelhouse, to enable the helmsman to see over cattle trucks.

Oban South Pier is the oldest of the Oban piers, dating from 1819, built by the Duke of Argyll, and used by Henry Bell's *Comet* on the pioneer steamer service to the West Highlands in that year. It has featured little in steamer history although it is believed that *Mountaineer* and Paterson's *Princess Louise* sailed from here. In recent years it has been used as a lay-by berth from the Lismore ferry, as seen here with two Island-class ferries in 1998.

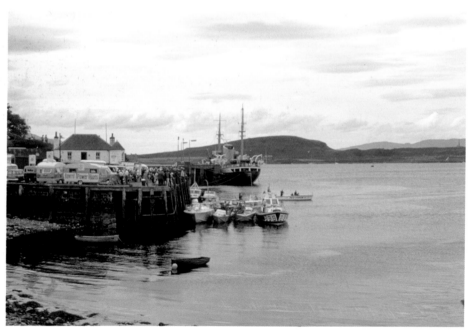

Competitors in a round Britain power boat race moored at the South Pier in 1969.

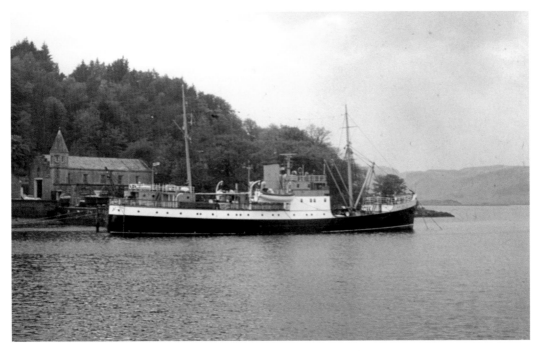

Further round from the South Pier is the Lighthouse Pier, normally used by vessels of the Northern Lighthouse board. *Hesperus* of 1939 is seen there in the early 1960s.

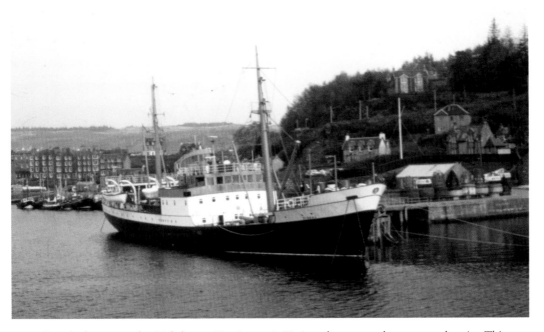

Fingal of 1964 at the Lighthouse Pier in 1978. Various buoys can be seen on the pier. This was the main depot for the servicing and maintenance lighthouses and buoys on the West Coast of Scotland.

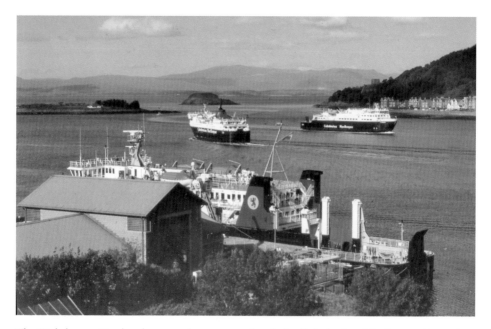

The Lighthouse Pier has been used as a spare berth for Caledonian MacBrayne from time to time when space is tight at the linkspans and North Pier. *Lord of the Isles* is seen there on 10 October 2006 with *Isle of Mull* arriving from Craignure and *Clansman* departing for Castlebay and Lochboisdale.

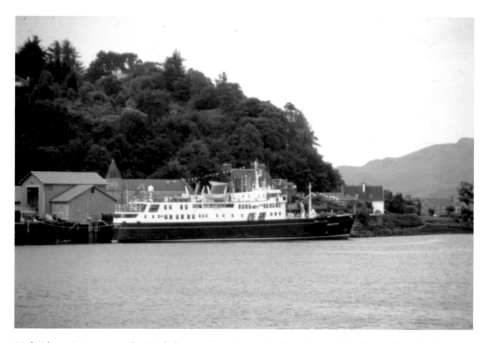

Hebridean Princess at the Lighthouse Pier in 2008. Use of the Lighthouse Pier by her and other small cruise ships has become more frequent with the lack of berthing space at the Railway pier and the building of the second linkspan there.

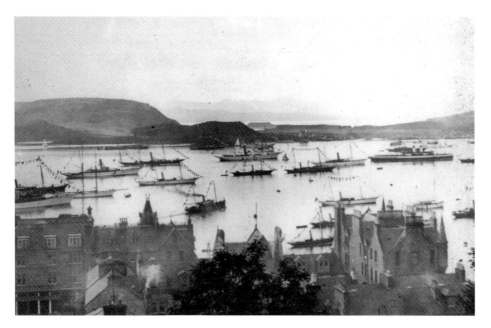

Berthing space has always been at a premium in Oban. This 1902 shot shows the Clyde turbine steamer *Queen Alexandra* berthed in the bay along with a large number of steam yachts, which are there for the Royal Highland Yacht Club Regatta.

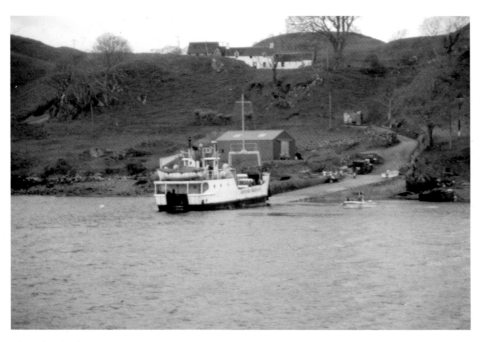

The island of Kerrera has a small slipway, normally served by the small landing-craft type ferry *Gylen Lass*, which runs directly across from the mainland. When heavy materials or a tractor are needed on the island a special run is made by a CalMac Island-class ferry, like *Bruernish* here in 1998

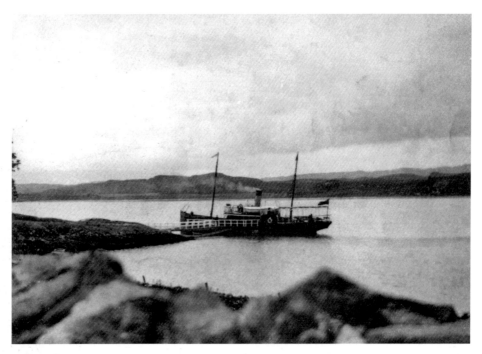

Dunstaffnage Castle was served from Oban by a twice-daily service by Paterson's *Princess Louise*, seen there. This was to a pontoon rather than a fixed pier.

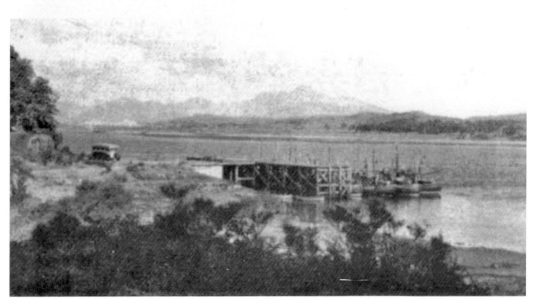

By the 1920s or 1930s the pontoon had been replaced by a fixed pier, although in more recent years a pontoon has again appeared there, serving the vessels of the Scottish Marine Institute.

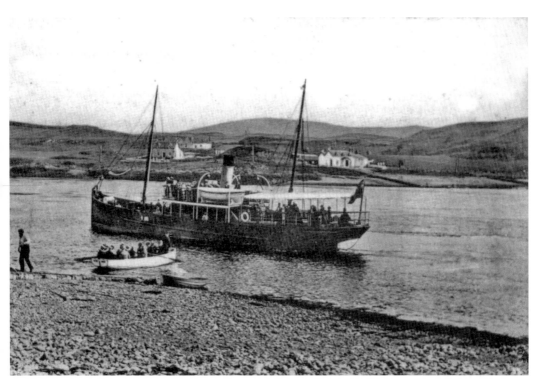

Princess Louise also called at Connel Ferry, where a ferry call was made.

Chapter 3

Piers of Loch Linnhe and Loch Leven

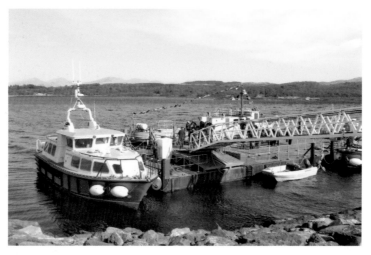

Rubha Garbh on Loch Creran is the base for Foster Yeoman, who run a private ferry service for their workers to their giant quarry at Glensanda on the other side of Loch Linnhe. The pontoon here was used by Clyde Marine's *Rover*, partly hidden in this shot, on a special sailing to Loch Leven and Loch Linnhe on 30 April 2011.

Further up Loch Creran, almost at the bridge, is Barcaldine Marina, where the small cruise vessel *Lord of the Glens* was berthed overnight on the same day because there was no berthing space at Oban on that occasion.

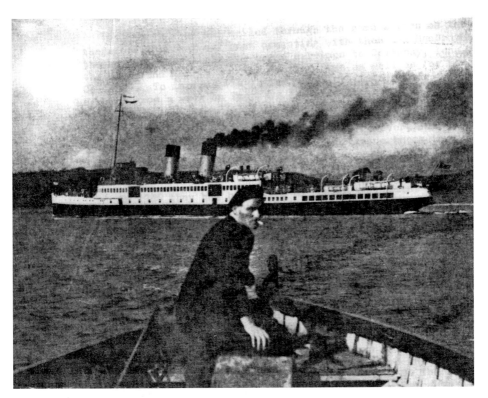

Port Appin was a call on the Oban–Fort William service and had a long pier in use until *c.* 1914 and was a ferry call from then until the service ceased in the early 1970s. *King George V* is departing *c.* 1948 and the ferry returning to the port.

Port Appin from the passing *Waverley* at some time in recent years.

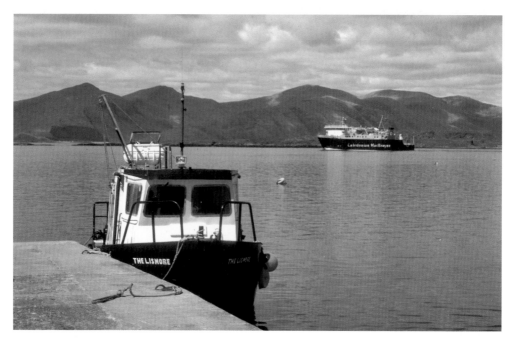

A passenger ferry service, run by Argyll and Bute Council, operates from Port Appin to the north end of Lismore with *The Lismore*, pictured. *Lord of the Isles*, on a 'Castles Cruise' can be seen in the background

The ferry landing place at the end of the road at the northern end of Lismore.

Ardsheal House, at the northern end of the Ardsheal Peninsula, had a small stone jetty, now abandoned, possibly used for building materials for the house, or for timber handling.

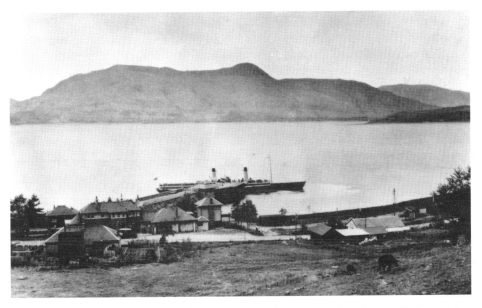

Kentallen Pier adjoined the station of that name and was opened in 1903 with the opening of the Connel Ferry to Ballachulish railway. Calls ceased with the outbreak of war in 1939. *Iona* is seen berthed at the pier in 1935 during her final spell on the Oban to Fort William service. The station buildings survive and have been extended over the platforms to form a hotel and restaurant.

The remains of Kentallen Pier in 2011.

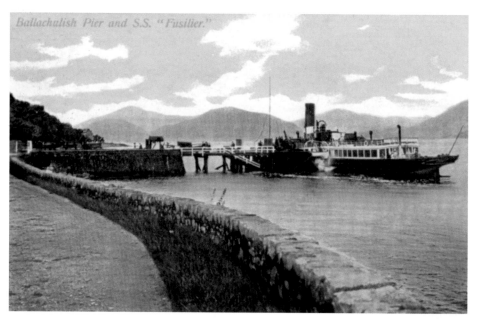

Ballachulish Pier was in use from 1880 on the Oban–Fort William service, but was, in the main, replaced by Kentallen when the latter was opened. *Fusilier* is seen there in an Edwardian postcard view.

Some piles from Ballachulish pier survive, and are seen here in 2011.

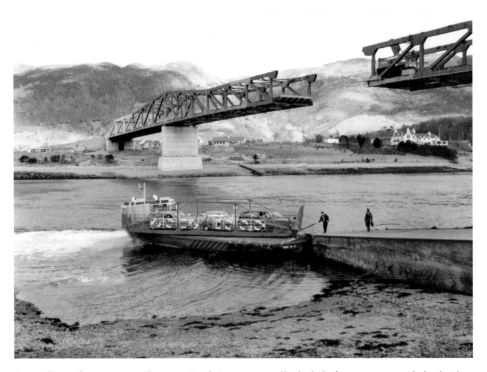

A small car ferry operated across Loch Leven at Ballachulish from 1906 until the bridge, seen under construction here, was opened in 1975. The ferry crossing itself is very old, dating back to the late seventeenth century.

The ferry ramp at North Ballachulish seen from *Rover* on 30 April 2011. Note those on the ramp photographing *Rover*, including enthusiast Stuart Cameron to the right.

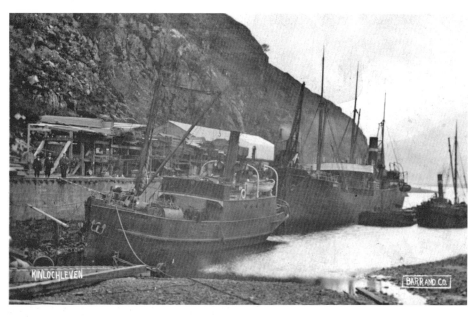

Kinlochleven was developed from 1905 onwards as the location of an aluminium smelter, which was powered by a major hydro-electric scheme fed from a dam in the hills behind. The lack of good roads along the shore of the loch meant that all men and materials had to come in by sea. MacBrayne's *Brenda*, a Kelly coaster and a puffer are seen there in this view.

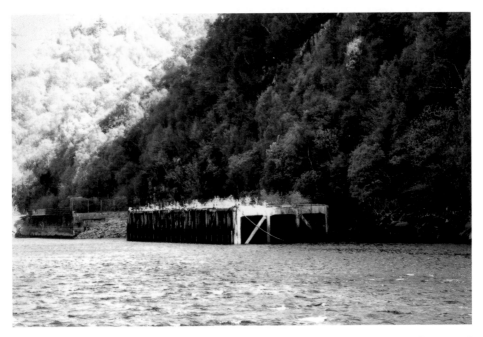

A road along the south side of the loch was completed in 1922 and the very basic road along the north side was improved in 1947. The smelter closed in 2000, although the hydro-electric scheme continues to supply the National Grid. This is the remains of one of the piers at Kinlochleven in 2011.

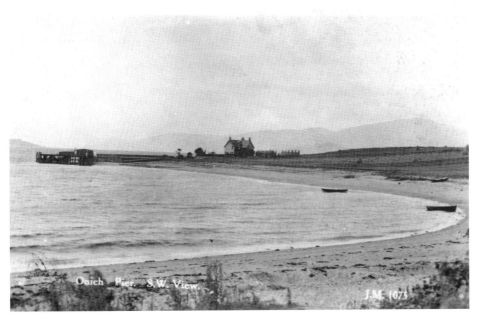

Onich Pier, on the northern shore at the mouth of Loch Leven, was opened in 1885 for the MacBrayne Oban to Fort William steamers and closed in the early 1930s.

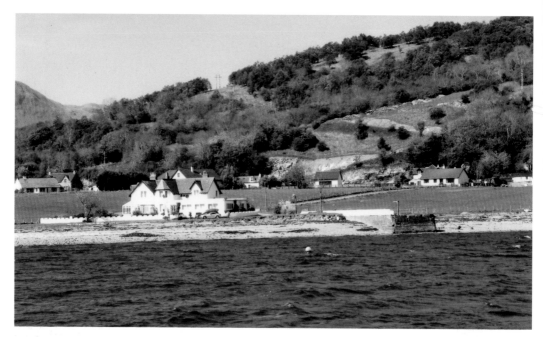

The remains of Onich Pier in 2011 as seen from MV *Rover* on a special 'Piers of Loch Linnhe' cruise..

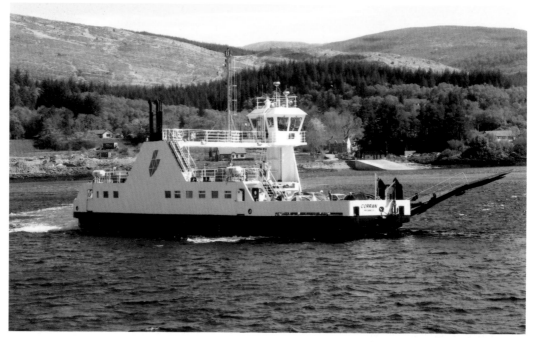

The Corran Ferry runs from Corran slipway, in the background, just off the main A82 road, to Ardgour. There has been a ferry here since the fifteenth century and a vehicle ferry since the late 1930s. The current ferry, *Corran* (2001), operated by Highland Council, is seen here in 2011.

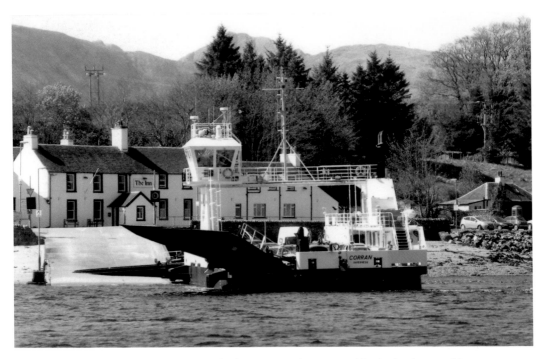

Corran at the Ardgour slipway with the Inn at Ardgour Hotel in the background in 2011.

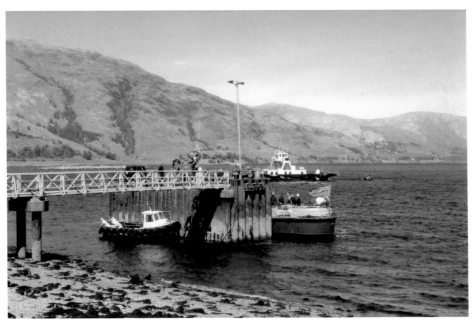

There has been a steamer pier at Ardgour since at least 1862, although for much of its life it appeared in the timetable as Corran rather than Ardgour. It is seen here on 30 April 2011, with *Rover* berthed on the aforementioned cruise, and the relief car ferry, *Maid of Glencoul* (1975), formerly at Kylesku, in the background.

The tidal conditions necessitated an unusual method of disembarkation from *Rover* on that occasion. The pier sees practically no use nowadays.

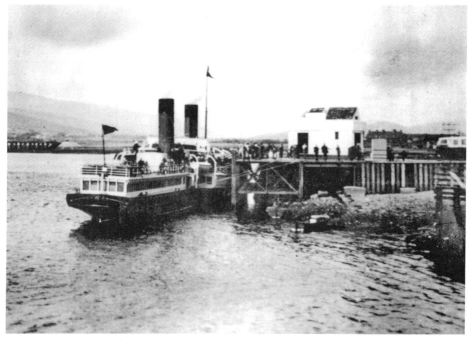

Fort William has had a pier since 1832, with the present one having been completed in 1871. In the 1930s, MacBrayne's built one of their white art deco pier buildings on the pier, similar to those at Port Ellen and Tobermory. *Iona* is seen there *c*. 1932.

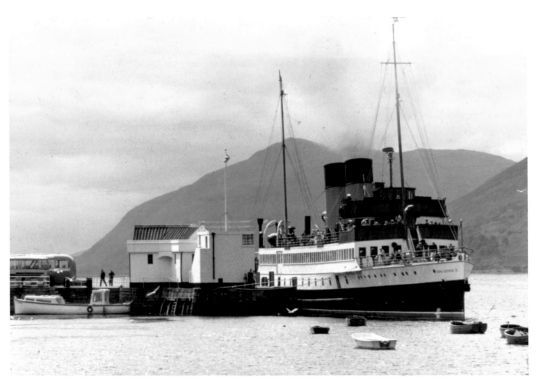

King George V at Fort William in the 1960s with a MacBrayne bus on the pier.

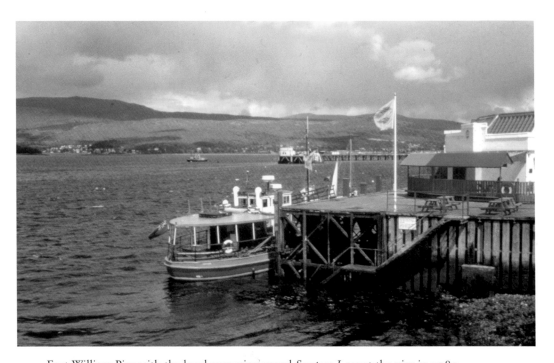

Fort William Pier with the local excursion vessel *Souters Lass* at the pier in 1989.

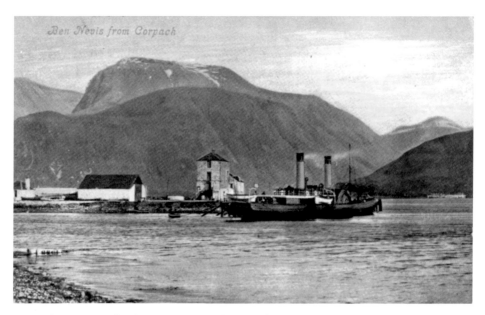

Corpach Pier outside the entrance to the Caledonian Canal was the final destination of the steamers from Crinan and Oban until 1895, when the railway was opened from Fort William to Banavie. Prior to that there was a coach connection to the top of Neptune's Staircase (the flight of locks) to connect with the Caledonian Canal steamer. *Pioneer* of 1844 is seen there in her later years in a classic view with Ben Nevis in the background.

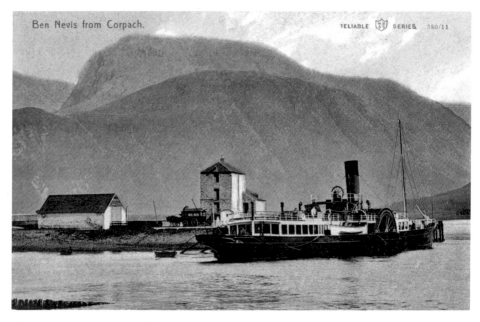

Fusilier at Corpach Pier, with the connecting horse and carriage for Banavie at the foot of the white building. In 1898, there were four departures from Oban to Fort William daily, but only the last departure in the evening at 1705 continued to Corpach, lying there overnight and sailing back the next morning at 0500, which connected at Oban with the steamer to Crinan.

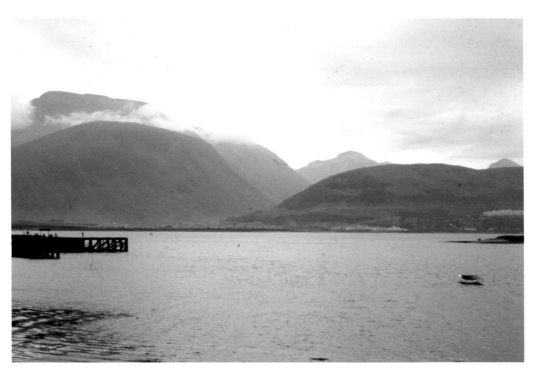

The remains of Corpach Pier in the 1960s.

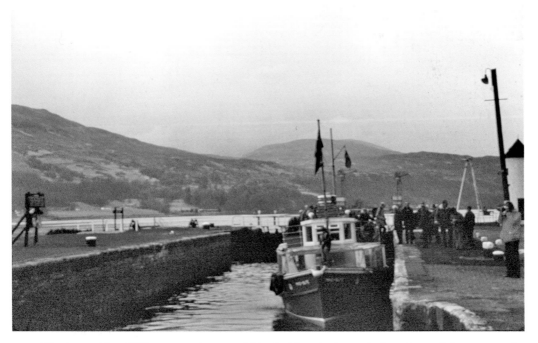

The former Fort William excursion vessel *Maid of Bute* in the sea lock at Corpach in 1979 on the occasion of a special Coastal Cruising Association cruise up the canal.

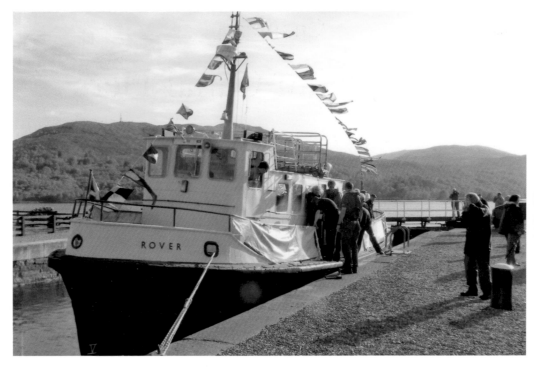

Rover in the sea-lock at Corpach on the special Loch Linnhe trip on 30 April 2011.

Souters Lass moored overnight in the canal basin at Corpach on the same occasion, to enable *Rover* to berth at Fort William Pier.

Chapter 4

Caledonian Canal Piers

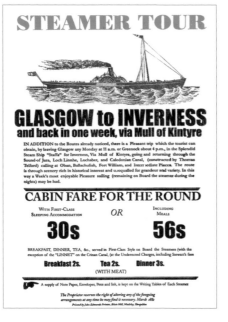

A service from Glasgow to Inverness via the Caledonian Canal was established by 1828, shortly after the canal was fully opened in 1822. This handbill, which is a demonstration item from a historic print shop in Blists Hill Victorian Town Museum, Shropshire, shows a paddle steamer, but is dated 1881, when the screw steamer *Staffa* (1863) was operating a weekly service from Glasgow to Inverness via the Mull of Kintyre.

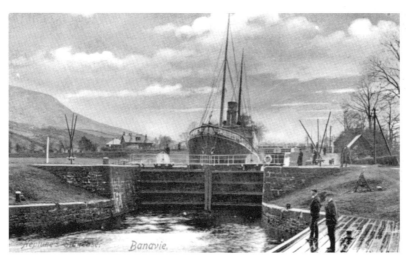

Cavalier was built in 1883 for the Glasgow to Inverness service, continuing it single-handedly after *Staffa* was lost in 1886 off Gigha. She took almost a week for the round trip, departing at 1300 on a Monday and returning on a Friday afternoon, and is seen here descending Neptune's staircase, the flight of locks down from Banavie to Corpach. She was sold in 1919 and the through service ceased.

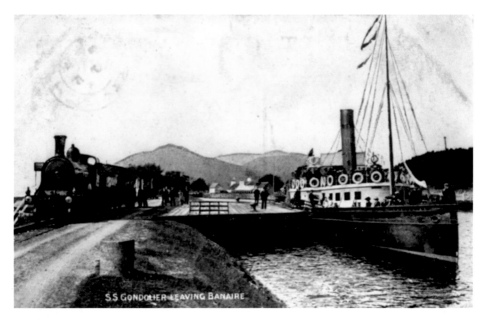

Gondolier of 1866 awaits the arrival of passengers at Banavie from the connecting train from Fort William. She maintained the service up the canal to Inverness until the outbreak of war in 1939, alternating daily with *Glengarry*, formerly *Edinburgh Castle*, a veteran from 1844, until 1894, then *Gairlochy*, formerly *Sultan*, until 1919, and *Glengarry* again until her withdrawal in 1927, sailing thrice weekly in each direction after that.

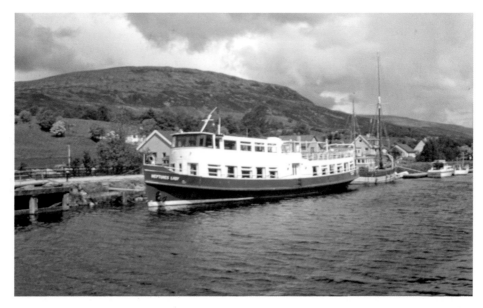

The former Dutch excursion vessel *Neptune's Lady*, which ran trips from Banavie in 1988, laid up there in spring 1989. Of the 60-mile length of the canal, only 22 miles are in an actual man-made canal, the remainder being on lochs Lochy, Oich and Ness, with a total of 29 locks.

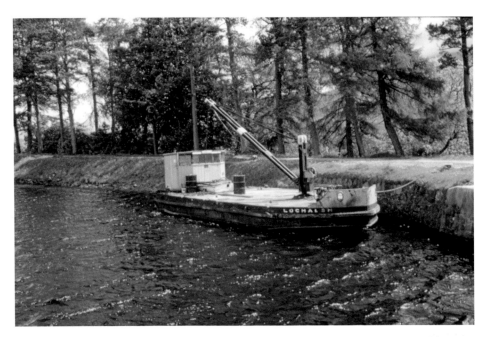

The former Kyle–Kyleakin ferry *Lochalsh* (1951), which had been in use as a workboat on the canal, on the other side of the canal at Banavie in 1989.

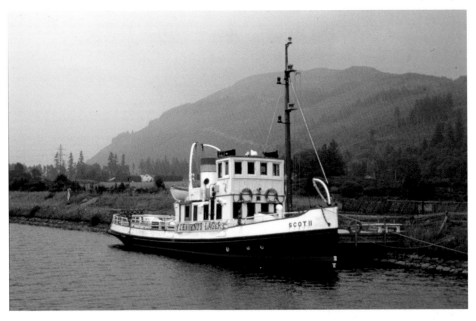

The canal heads north for Gairlochy, where there are two locks before it enters Loch Lochy. This was a calling place for the MacBrayne steamers. At the north end of Loch Lochy there is another lock at Laggan, also a steamer calling point, then the canal passes a tree-lined section known as Laggan Avenue. Around here, the former Inverness excursion vessel and canal icebreaker *Scot II* was moored as a floating pub for a while, seen here in 1994.

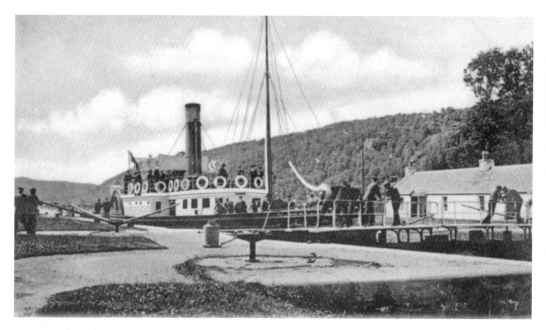

The canal, by now at its highest point of 106 feet above sea level, then joins Loch Oich, and passes locks at Cullochy and Kyltra, the former an official steamer calling point. *Gondolier* is seen here descending Kyltra Locks in an Edwardian postcard.

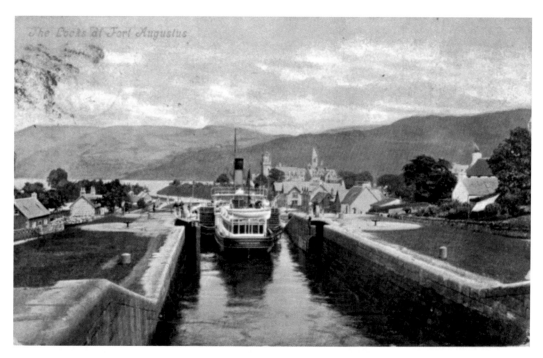

At Fort Augustus there was a small flight of five locks to bring the canal down to the level of Loch Ness. *Gondolier* is seen descending them in this Edwardian postcard.

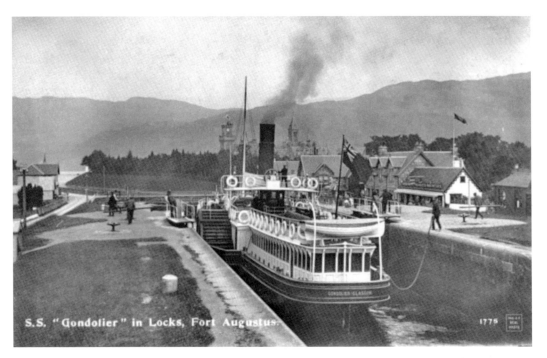

S.S. "Gondolier" in Locks, Fort Augustus. 1779

A sepia view of *Gondolier* in the locks at Fort Augustus. Note the lockkeeper handling the rope and the shop to the right with the sign indicating it was a cabinetmaker and walking-stick manufacturer.

Scot II at Fort Augustus in 1974 on a Coastal Cruising Association charter.

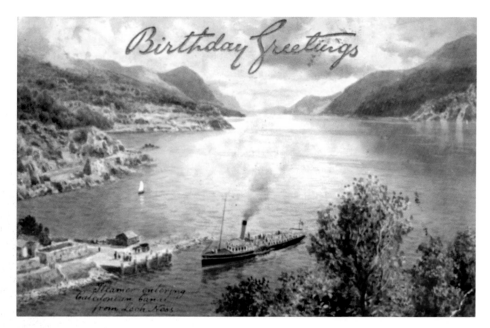

Fort Augustus also had a steamer pier in Loch Ness below the locks, as seen in this *Tucks Oilette* postcard, which has been adapted for use as a birthday card and was posted in 1908.

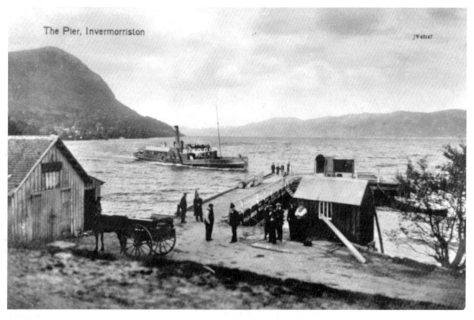

The first of several calls going up the loch was Invermoriston on the western shore. Until the First World War MacBrayne's operated a Loch Ness mail service in addition to the through trips from Banavie and Glasgow. The steamer *Lochness* of 1851, which maintained the service from 1885 until scrapping in 1912, is seen here approaching the pier.

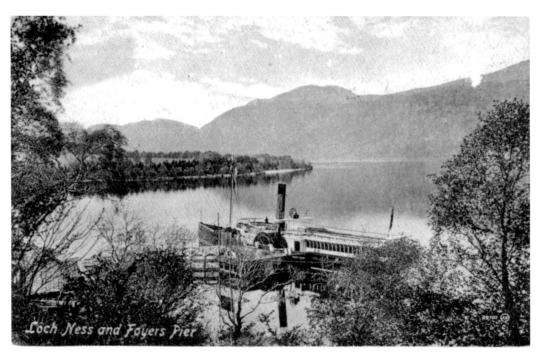

Loch Ness and Foyers Pier

The next call was Foyers on the eastern bank, seen here with *Glengarry* at the pier in a postcard view.

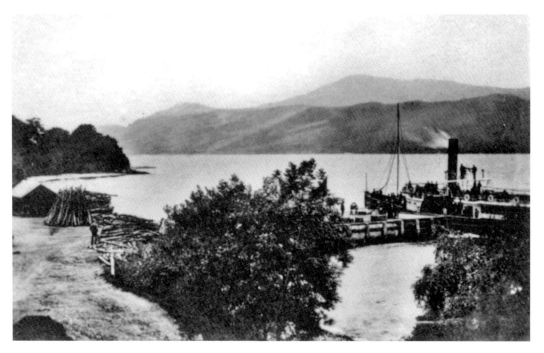

There followed a call at Inverfarigaig, on the eastern shore. *Gondolier* is seen there in a postcard view.

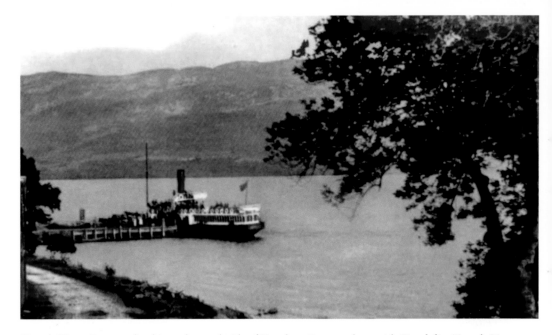

Temple Pier at Drumnadrochit on the north side of Urquhart Bay, seen here with *Gondolier*. Temple Pier is now used for excursion boats on trips to search for the Loch Ness Monster. There is also a modern jetty at Urquhart Castle, across the bay, used by Jacobite Cruises. North of Temple Pier there was a pier at Abriachan, which was noted in the 1898 MacBrayne guide book as being under construction, and also at Aldourie, a large house at the top of the loch. Near Abriachan is the Clansman Hotel and the adjacent Clansman Harbour, used by Jacobite Cruises for short trips on Loch Ness

Dochfour on Loch Dochfour. Note the railway posters on the pier, although the pier does not appear in any MacBrayne timetable available to the author at the time of writing. The Midland Railway advertisement would indicate that it is pre-1923. Further north is the lock at Dochgarroch, where Loch Ness joins the canal towards Inverness. With a coach connection to Inverness, Dochgarroch was used as the terminal point for a service from Gairlochy, with a coach connection from Fort William, by the first *Glencoe*, formerly *Lochlomond*, fromn 1846 to *c.* 1849 for William Ainslie of Fort William. (UBC Botanical Garden Archives, JD.2005.680.0789)

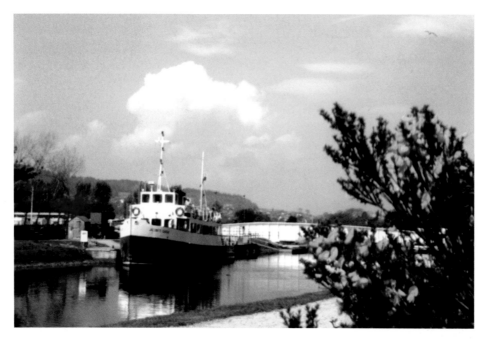

Jacobite Cruises operate from a berth at Tomnahurich Bridge, where the A82 crosses the canal, on cruises to Loch Ness and Urquhart Castle. *Jacobite Queen* is seen there in this shot.

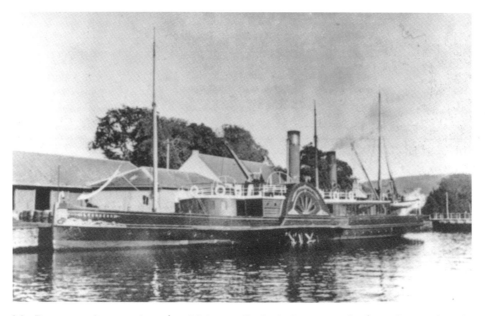

MacBrayne services terminated at Muirtown Basin, in Inverness. *Lochness* is seen there in this shot, probably during her mid-day layover. The 1898 timetable shows that she left Fort Augustus at 0600, arriving at Inverness at 0920, not departing again until 1500 and getting back to Fort Augustus at 1830.

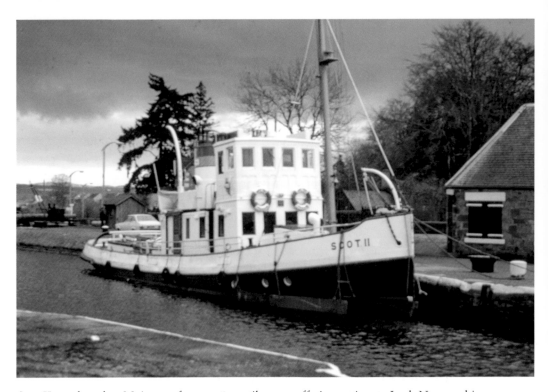

Scot II was based at Muirtown from 1961 until 1991, offering cruises to Loch Ness, and is seen there in 1978.

Chapter 5

Mainland Piers from Lochaline to Glenelg

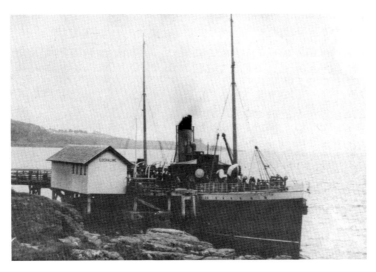

Lochaline Pier was built in 1883, and was used by the Sound of Mull mail service, and by a car ferry service from Oban via Craignure by *Columba* from 1964 until 1973. *Lochbroom* is seen there in the 1930s, probably while on one of her long cruises from Glasgow right up the West Coast to Loch Clash Pier at Lochinchard.

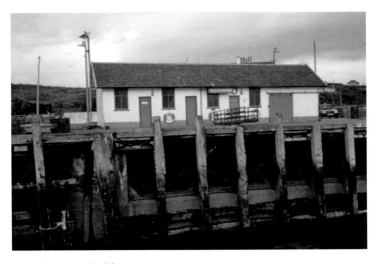

Lochaline Pier buildings in 1983.

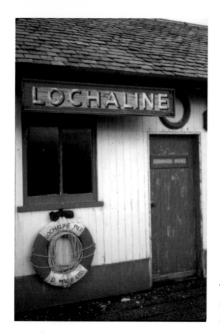

The pier sign at Lochaline in 1983, still in MacBrayne red some ten years after the formation of Caledonian MacBrayne.

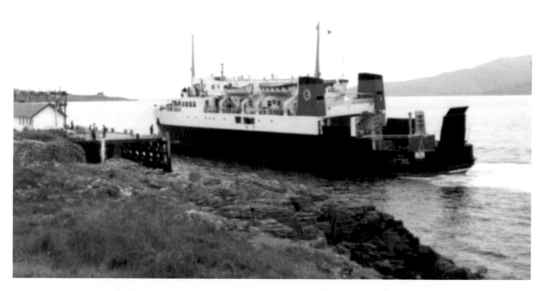

Iona arriving at Lochaline in 1975 en route back to Oban from Lochboisdale and Castlebay. With sailings going direct to these ports and the calls at Coll and Tiree being served by a seperate service, the former called at Lochaline for a few years for certification purposes, the crossing time from Oban to Castlebay being too long for the relevant passenger certificate. The pier has seen little use by ferries in recent years, although until 2008 it had heavy use by cargo vessels with cargos from the silica sand mines there, which at the time of writing are scheduled to reopen..

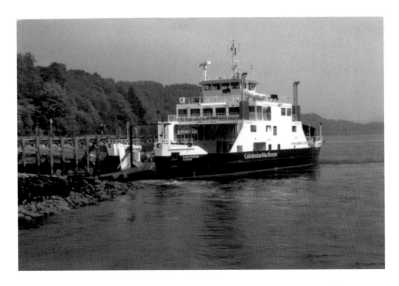

There has been a car ferry service from Lochaline to Fishnish on Mull since 1973. *Loch Portain* is seen there for berthing trials on 31 May 2003 as a new ship, having left her builder's yard in the Mersey the previous day. She was en route for her normal service in the Sound of Harris. There was a ferry call at Drimnin further down the Sound of Mull until the cessation of the Sound of Mull mail service in 1964. It has been served in recent years by a small boat from Tobermory.

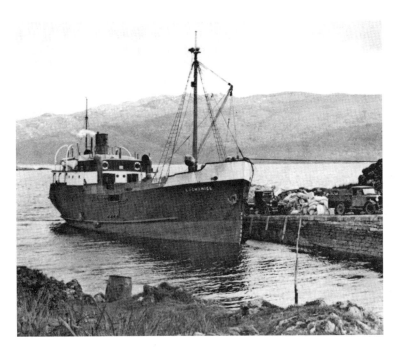

Loch Sunart was served as an extension of the Sound of Mull mail service up to the early 1900s, with calls at Salen and Strontian. The cargo service continued until about 1951 and also called at Glenborrodale, Glencripesdale and Laudale on the south side of the Loch. Cargo steamer *Lochshiel* is seen at Salen in the 1930s.

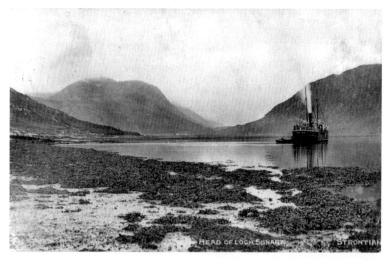

Strontian is at the head of Loch Sunart. There were lead mines here where the element Strontium was discovered. *Handa*, on the cargo service from Glasgow to Loch Sunart via the Crinan Canal, is seen anchored there in this postcard view posted in 1913.

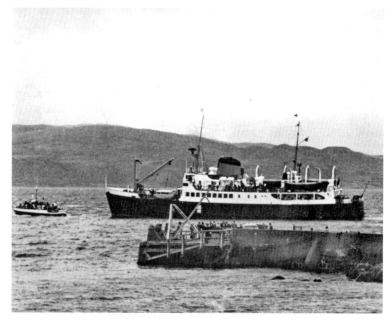

Mingary Pier, also known as Kilchoan, is on the mainland opposite Tobermory. In the 1890s it was served by the steamer from Oban to Coll, Tiree and Bunessan, and from the 1930s by the Inner Islands mail steamer to Coll, Tiree, Castlebay and Lochboisdale. The 1947 mail contract specified a dedicated service from Tobermory to Mingary, operated initially by *Lochbuie*, and from 1968 to 1981 by *Lochnell*. *Claymore* made an annual call for the Tobermory Games Day, and is seen there on 22 July 1971. Due to lack of water, she lay off the pier and was tendered by *Lochnell*, as seen here.

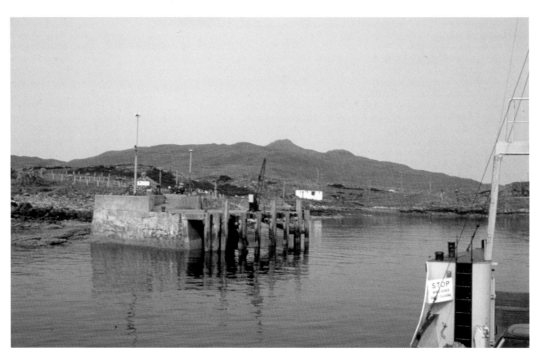

In 1991, a slipway was built at Kilchoan and a car ferry service commenced from Tobermory with the Island-class ferry *Coll*, which had served the route for passengers only since 1986. The pier is seen from *Coll* in 1994.

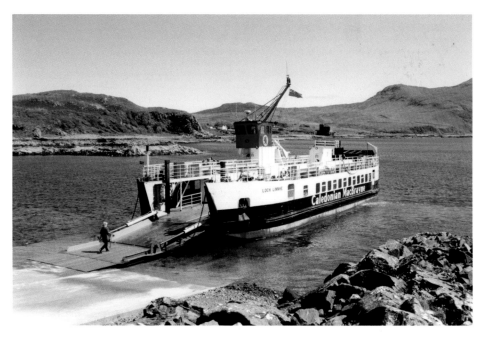

In 1999, the Island-class car ferry *Loch Linnhe* took over the route and she is seen here at the slipway at Kilchoan.

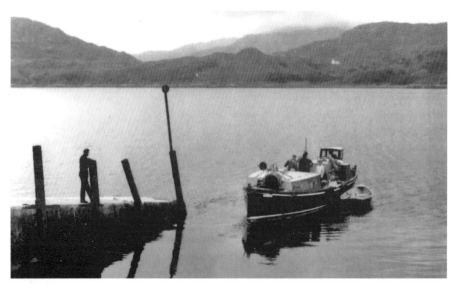

Prior to the opening of the A861 road from Lochailort to Acharacle in 1967, the motor launch *Jacobite* maintained a mail service down Loch Ailort from Lochailort, where she is seen here, to Glenuig.

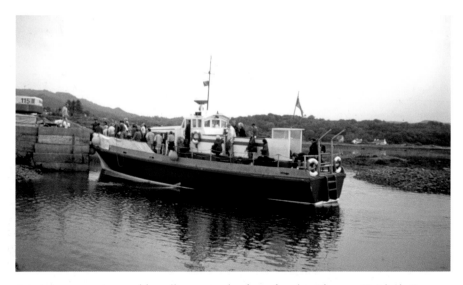

Arisaig was a twice weekly calling point by ferry for the Oban to Gairloch Steamer *Gael*, and for *Claymore* and *Clansman* en route from Glasgow to Stornoway in the 1880s and 1890s. With the opening of the West Highland Railway Extension to Mallaig in 1901, the calls at Arisaig ceased. From 1972 until 2002 *Etive Shearwater*, a 1940-built former Harbour Defence Motor Launch, seen here at Arisaig in 1994, offered trips to the Small Isles from here for Arisaig Marine. She was succeeded by the more modern *Shearwater*, which continues to operate these trips.

A list in the 1898 guidebook shows Salamalan and Roshven as calls with a note 'See Special Sailing Bills'. Salamalan was noted as an occasional call by one of the Glasgow to Stornoway steamers in 1885.

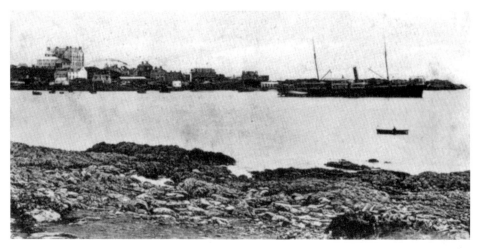

Mallaig only came into existence with the opening of the West Highland Railway Extension from Fort William in 1 April 1901. The Portree and Stornoway mail services, initially with *Lovedale* and *Clydesdale*, and from 1904 *Glencoe* and *Sheila* respectively, were extended south to there from Kyle of Lochalsh, and the three steamers that had called at Arisaig also moved to Mallaig. *Claymore* is seen here at Mallaig in a postcard view posted in 1904. *Clansman* was replaced by *Chieftain* in 1907, and after the First World War the Gairloch service ceased and the Glasgow to Stornoway service was cut down to a weekly sailing by *Claymore*, replaced in 1931 by *Lochbroom*, which was herself replaced in 1937 by *Lochgarry*. The passenger service finally ceased in 1940 when she was requisitioned for war service and replaced by the cargo steamer *Lochgorm*.

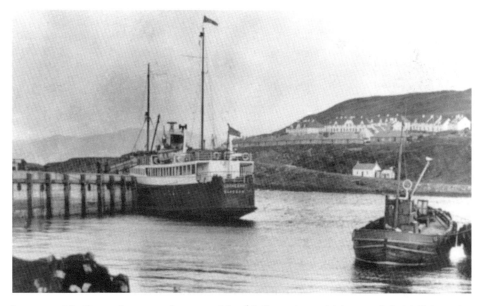

In 1930, MacBrayne's recast the outer isles Mail service, which now left Mallaig twice weekly in summer for Lochboisdale and Lochmaddy via the Small Isles, returning via Harris and Kyle of Lochalsh with the sailing twice weekly in the other direction, normally maintained by *Lochmor*, although sister *Lochearn* is seen in this view at Mallaig.

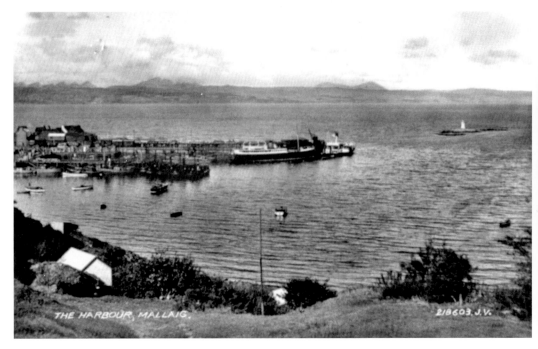

Lochmor or *Lochearn* with the paddle steamer *Fusilier* at Mallaig in the early 1930s. The latter replaced *Glencoe* on the Portree service in 1931 and was herself replaced by the new motor vessel *Loch Nevis* in 1934.

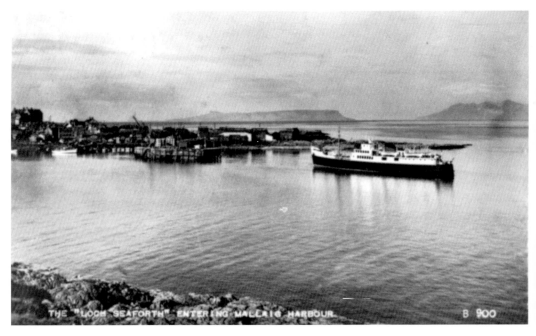

Sheila had been lost in 1927 and was replaced by the new *Lochness* two years later, which was herself replaced by *Loch Seaforth* in 1947, which is seen arriving at Mallaig in a 1950s postcard view.

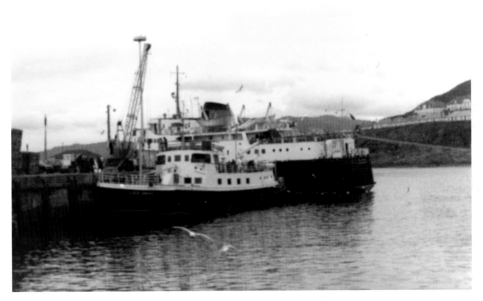

In 1964, a car ferry service to Armadale was introduced with *Clansman*, and the following year *Loch Arkaig*, a converted wooden-hulled inshore minesweeper, started a dedicated service from Mallaig to the Small Isles. Both are seen there in the early 1970s.

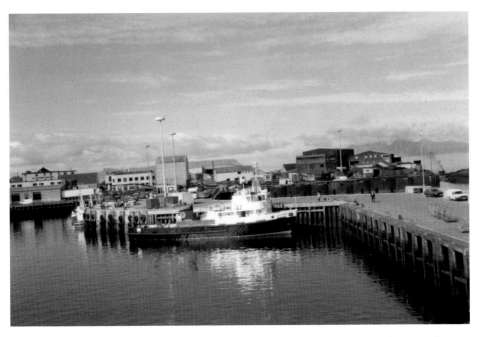

On 18 July 1979, the new *Lochmor*, seen here, replaced *Loch Arkaig*, which was really past her best and had sunk at her moorings at Mallaig on 28 March of that year.

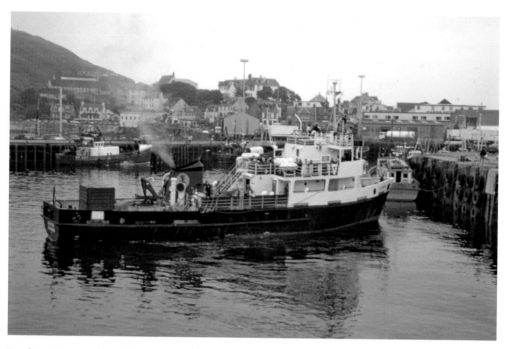

Lochmor is seen here departing Mallaig for the Small Isles in 1994. She also offered a winter service to Armadale.

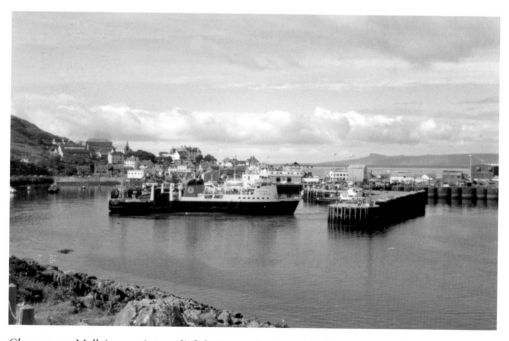

Claymore at Mallaig on winter relief duties on the Armadale ferry service. *Clansman* had been replaced by *Columba* in 1973, followed by *Bute* in 1975, *Pioneer* in 1979 and *Iona* ten years later. This view shows the extent of the harbour extensions by the 1980s.

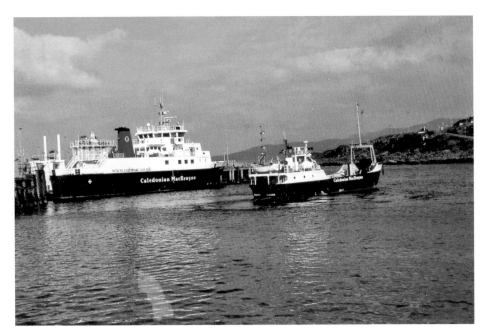

In 2000, the new *Lochnevis* replaced *Lochmor*. She is seen here at Mallaig, with the Island-class car ferry *Raasay* departing. It is likely that *Lochnevis* was just back from overhaul and the smaller vessel had been relieving on the route and was returning south to Oban or Tobermory.

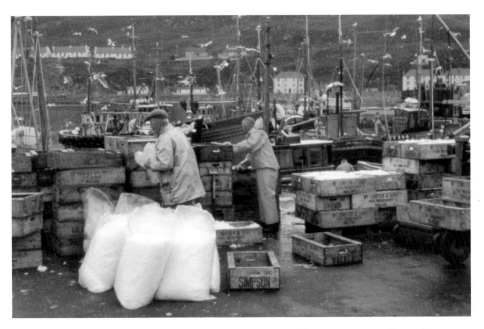

Mallaig was for many years a major fishing port and here, in a view from the 1960s, fishermen are packing boxes of fish ready for shipment to the major population centres further south. The white bags will be full of ice.

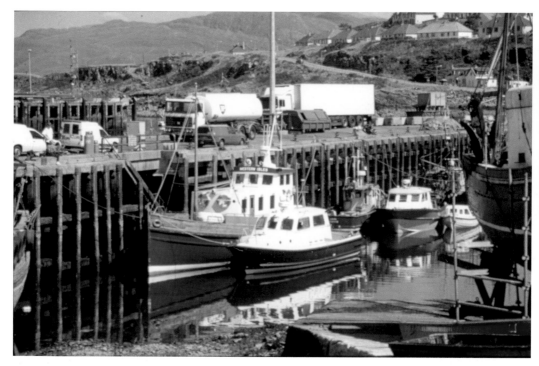

Since 1960 the mail service to the remote Loch Nevis locations of Inverie and Tarbet has been maintained by Bruce Watt's passenger boat *Western Isles*, seen here at Mallaig in 1997.

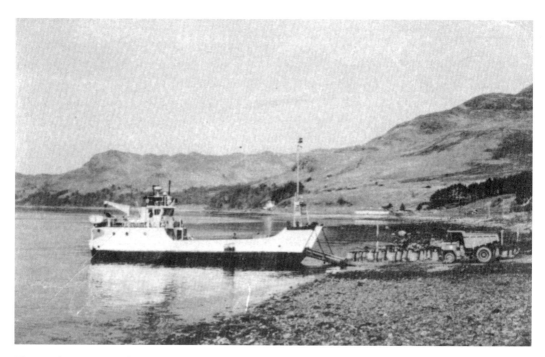

The car ferry *Bruernish* on an unusual call at Inverie with heavy equipment on 17 May 1978.

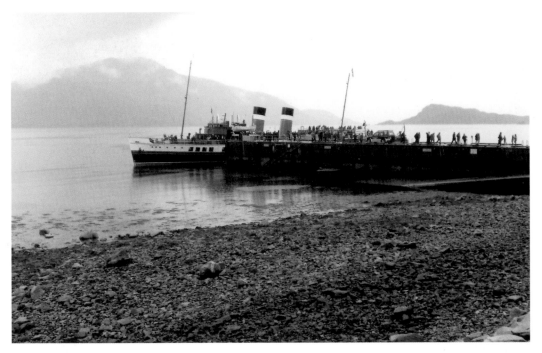

Inverie is extremely isolated, with no road access, and has the most isolated pub in Britain. A pier was not built here until 2006. *Waverley* is seen there, on what has become an annual call, in 2009. In the 1880s and 1890s Inverie was an occasional call for the Glasgow to Stornoway steamers.

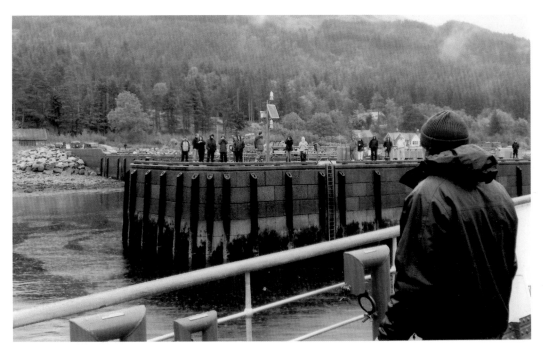

Inverie pier, seen from the arriving *Waverley*.

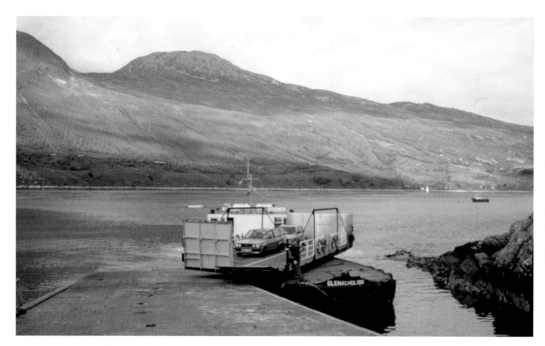

The ferry service from Glenelg to Kylerhea on Skye is still maintained in the summer months by the turntable car ferry *Glenachulish*, the last survivor of what was once a common type of ferry in the West Highlands. She is seen here just arrived at Glenelg in 1995. There has been a car ferry service there since 1934 and the ferry crossing goes back to at least the late seventeenth century, the narrows having been used by drovers driving cattle from Skye to the market at Perth. Glenelg was also a ferry call for MacBrayne steamers operating between Mallaig and Kyle of Lochalsh on the Portree and Stornoway mail services and the Outer Islands service.

Chapter 6
Piers of Wester Ross and Sutherland

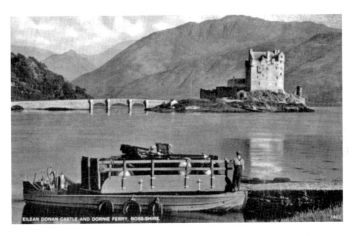

A small car ferry operated at Dornie across the mouth of Loch Long until the opening of a bridge in 1940. Totaig, near here but on the south side of Loch Duich, was an occasional call for the Glasgow to Stornoway steamers prior to 1914. Note Eilean Donan castle in the background of the image.

Balmacara, south of Kyle of Lochalsh, was a port of call for the MacBrayne steamers prior to the railway being opened to Kyle in 1897 and for a while after that. In this view, *Plover* is aground here at low tide for bottom cleaning or painting.

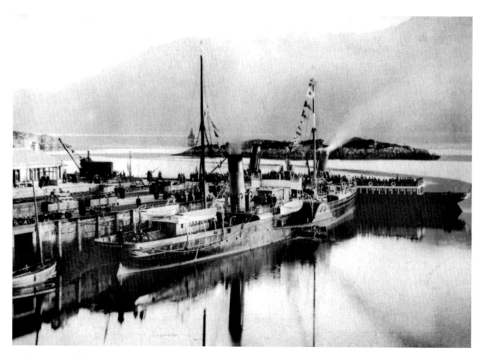

Kyle of Lochalsh on 2 November 1897, the opening day of the station and pier. *Lovedale* is in the foreground on the Portree service, and *Gael* across the end of the pier, heading southbound, en route from Gairloch to Oban.

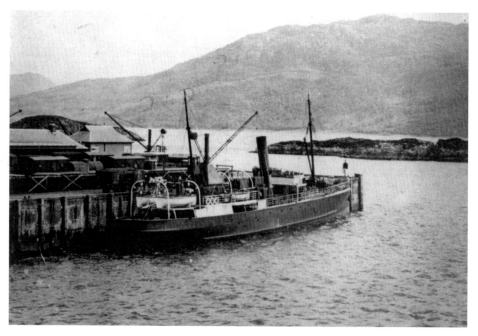

Sheila at Kyle when on the Stornoway service between building in 1904 and her loss near the mouth of Loch Torridon on New Year's Day 1927.

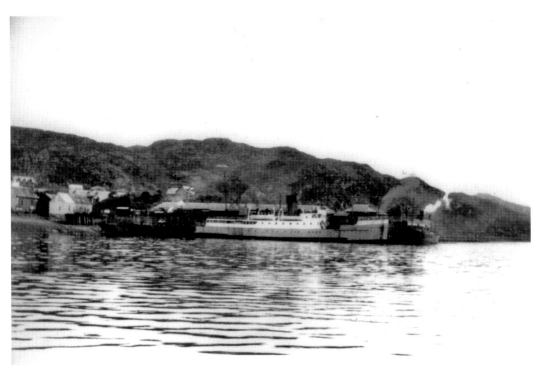

Stornoway steamer *Lochness* at Kyle in autumn 1929 in her brief grey-hulled condition.

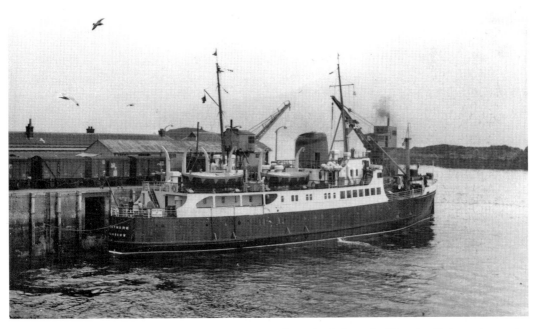

The 1955 *Claymore* at Kyle while relieving *Loch Seaforth* for refit. Note in all these photos the railway wagons at the station between the berth and the platform.

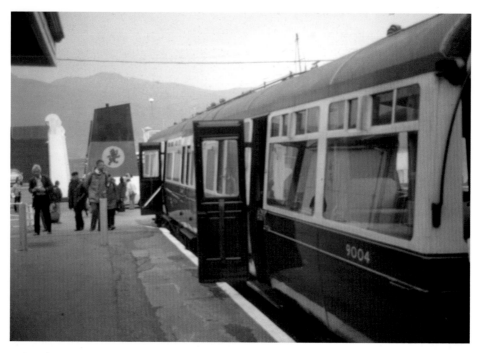

Kyle of Lochalsh station, with an enthusiast special recently arrived overnight from Liverpool and Manchester on 15 May 1982, which connected with a special sailing of *Pioneer*, whose funnel can be seen, round Skye.

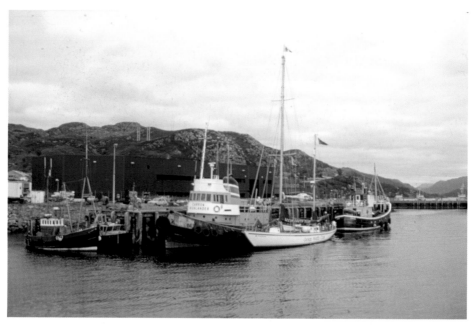

To the south of the pier is the Fishing Pier, seen in 1995 with the tug *Carron Highlander*, a yacht and a couple of fishing boats.

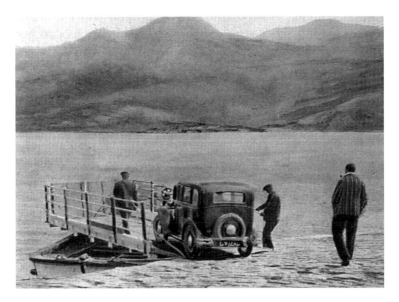

A car ferry service started between Kyle of Lochalsh and Kyleakin in 1918, although there had been a passenger ferry there since at least 1695, and cars had been carried prior to 1918, one at a time, on a flat-bottomed rowing boat or on a barge towed behind a motor boat. By 1900, there was a steam launch offering a passenger ferry service here. This is one of the first one-car motorised ferries, *Kyle* or *Kyleakin*, at the slipway at Kyle in the 1920s or 1930s. The ferries were owned by the Highland Railway, and the London Midland & Scottish Railway after the 1923 amalgamation of the old railway companies.

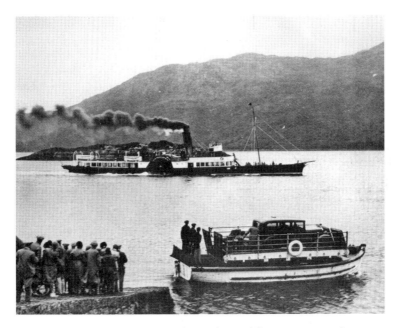

The 1928 car ferry *Kyleakin* leaving Kyle as the paddle steamer *Fusilier* passes on the Portree mail service in 1931. In 1934, the ferry service was leased to David MacBrayne Ltd and in 1942 a new ferry named *Culllin* was introduced to the route.

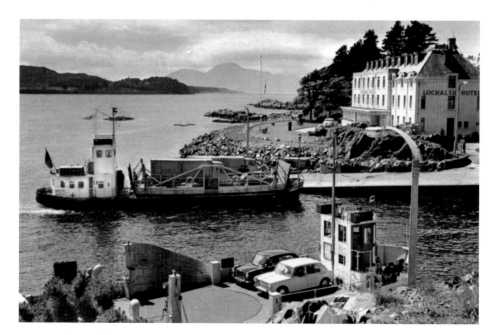

In 1945, the Caledonian Steam Packet Co Ltd took over the lease of the ferries, and in 1948, with the nationalisation of the railways, ownership passed to the Railway Executive (Scottish Region). New four-car ferries *Lochalsh* and *Portree* were introduced in 1951 and *Broadford* in 1954. A second *Lochalsh* followed in 1957 and *Kyleakin* in 1960, both with a six-car capacity. All of these were turntable ferries, although *Kyleakin* was converted to bow loading in 1972 before service on the Largs to Cumbrae slip run as *Largs*. A second loading ramp was added in 1961, and three side-loading nine-car ferries, *Portree*, *Broadford* and *Coruisk*, entered service in 1965, 1967 and 1969 respectively. They had with a turntable on the car deck.

In this postcard view from the 1960s, the 1965 *Portree* can be seen at the near ramp, note the turntable on the deck, with *Lochalsh* at the far ramp. Note the Railway-owned Lochalsh Hotel in the background.

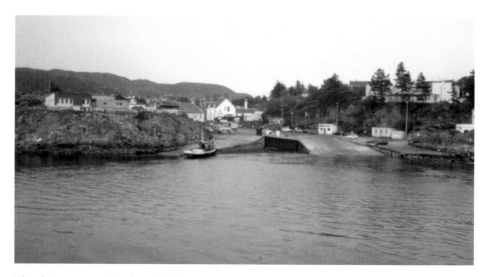

The slipways at Kyle of Lochalsh in 1982.

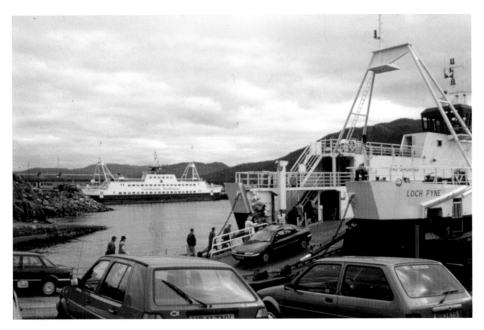

The drive-through ferries *Kyleakin* and *Lochalsh* entered service in 1971. Their twenty-eight-car capacity helped cut the increasing queues of cars heading for Skye. They were superseded by the thirty-six-car *Loch Fyne* and *Loch Dunvegan*, introduced in 1991, which were withdrawn from service four years later on the opening of the Skye Bridge on 16 October 1995. In this September 1995 view *Loch Fyne* is unloading, while *Loch Dunvegan* is lying by at the railway pier.

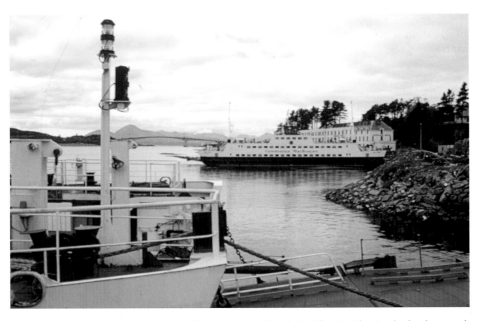

Loch Fyne, with *Loch Dunvegan* in the foreground and the Skye Bridge in the background, in September 1995.

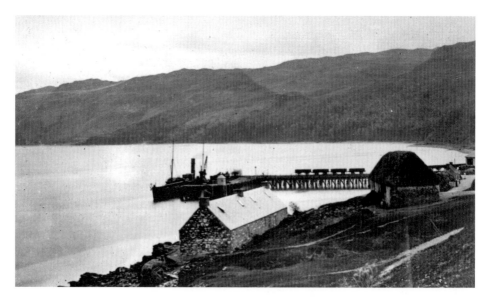

Before the railway was extended to Kyle of Lochalsh in 1897, it terminated at Strome Ferry, which had been reached by the Dingwall & Skye Railway in 1870. Steamers ran from there and the paddle steamer *Carham* is seen at the pier. There were tracks on the pier, and some trucks can be seen; presumably they would have brought coal for the steamers. The steamers were operated by the Dingwall & Skye Railway until 17 April 1880, when their services were taken over by David MacBrayne Ltd. The Dingwall & Skye Railway was taken over by the Highland Railway on 1 September 1880 and the pier was demolished in 1937.

Plockton was a port of call for the Strome Ferry to Portree service in the 1880s.

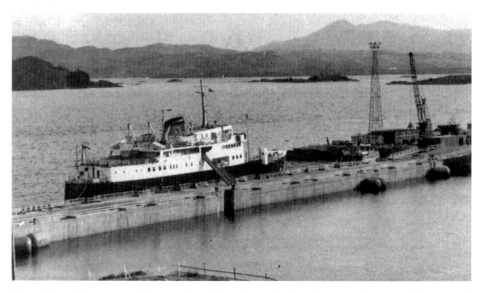

A small car ferry operated across Loch Carron at Strome Ferry until replaced by a road along the south side of the loch in 1970. On 12 May 1983, the Prince of Wales visited the Howard-Doris oil rig platform production yard at Kishorn, and *Columba* sailed from Strome Ferry, where she is seen here, on a rehearsal the previous day.

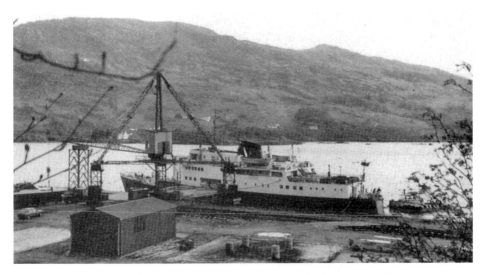

Columba at Kishorn on the same occasion.

Jeantown, now known as Lochcarron, was an occasional call by the Glasgow–Stornoway steamer in the 1880s.

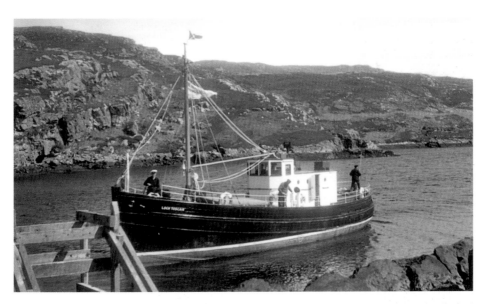

The Stornoway mail steamer made a ferry call at Applecross until 1956, when a dedicated service from Kyle of Lochalsh to Toscaig was commenced with the former motor fishing vessel *Loch Toscaig*, seen here at Toscaig in 1963. *Loch Toscaig* also operated a thrice-weekly Kyle–Kylerhea run from 1965 to 1972. The Toscaig service operated until 1975, when an all-year road opened round the north Applecross peninsula. Previously the only access had been on the notorious Bealach na Ba road, which was often closed by snow in the winter months. On occasion, from 1976 until 1978, the car ferry *Bruernish* sailed from Kyle of Lochalsh to Toscaig on charter to Howard-Doris Ltd., to ferry oil rig construction workers there.

The Glasgow to Stornoway steamer made occasional calls at Loch Torridon in the late nineteenth century.

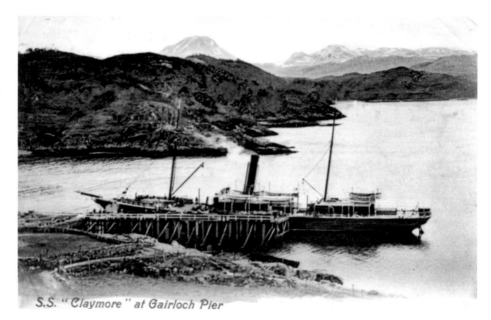

S.S. "Claymore" at Gairloch Pier

Claymore, pictured here, called at Flowerdale Pier at Gairloch weekly en route from Glasgow to Stornoway, from 1881 until her withdrawal in 1931, having left Glasgow at 1400 on a Thursday and arriving at Gairloch at 1000 on a Saturday. Gairloch was also served thrice weekly from Oban by *Gael* until 1914, leaving Oban at 0700 and arriving at Gairloch at 1800. All sailings went via Portree. In the 1880s, *Claymore* called at Poolewe after Gairloch.

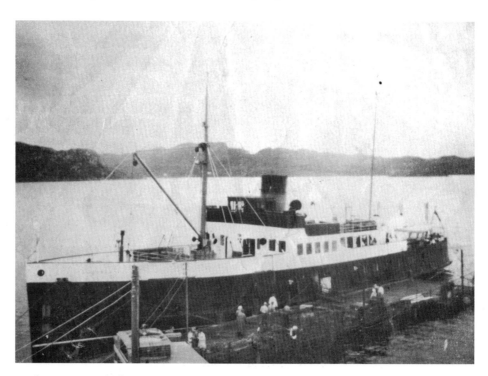

Lochnevis at Gairloch on an evening cruise from Portree on 7 August 1956.

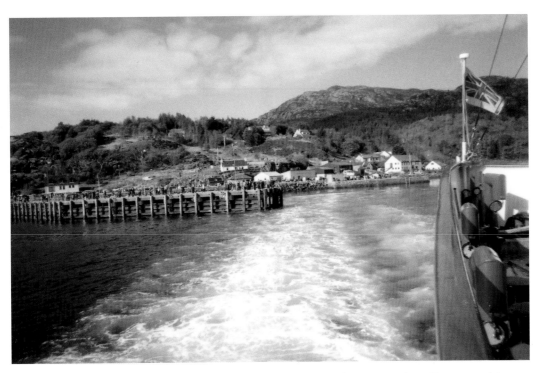

In late April 2011, *Waverley* made a unique call at Gairloch on a trip from Portree, and is seen here leaving. This was believed to be the first call there by a paddle steamer since *Gael* ceased running from Oban in 1914.

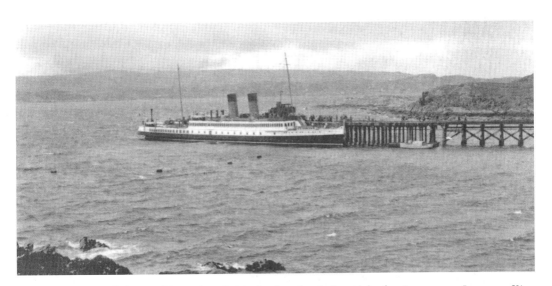

Claymore called at Aultbea after Gairloch, then headed straight for Stornoway. In 1970, *King George V* was scheduled to call at Aultbea on 19 May 1970 on her Highlands and Islands Development Board charter after a call in the morning, the pier was found to be unsafe and on her return she, instead, berthed at the Admiralty pier at Mellon Charles, two and half miles away, seen here.

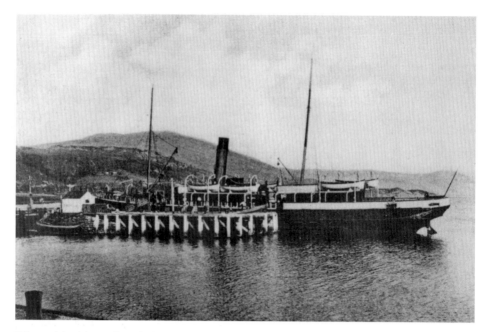

Ullapool had been founded by the late eighteenth century by the British Fisheries Society and the pier was completed in 1790. A service to Stornoway by the paddle steamer *Ondine*, owned by Stornoway provost Sir James Matheson, operated from 1871 until 1885. MacBrayne's three long-distance steamers, *Claymore*, *Clansman* and *Clydesdale* called there en route to Stornoway, and *Claymore* is seen here. In the 1880s and 1890s the Monday sailing from Glasgow with *Clansman* called at Ullapool and piers north from there.

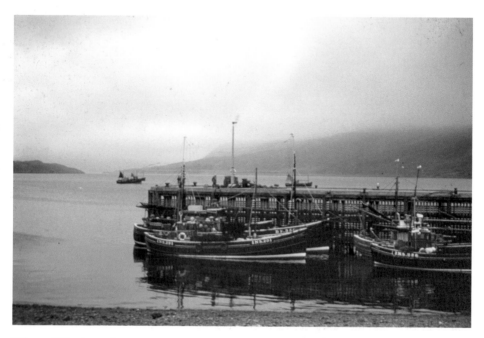

Ullapool Pier in 1961.

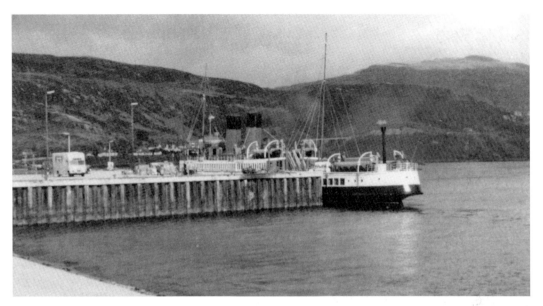

King George V also called at Ullapool on her 1970 HIDB charter, on 20–21 May, although bad weather meant that the planned cruises from there, including one to Tarbert (Harris), were cancelled.

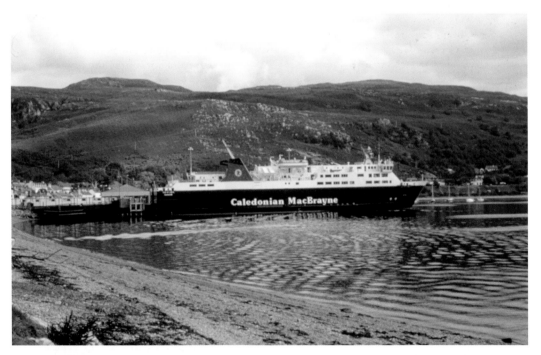

In 1973, a car ferry service to Stornoway was started from Ullapool, replacing the time-honoured route from Mallaig via Kyle. Initially, it was operated by *Iona*; by the end of the year *Clansman*, newly converted to drive-through operation, was on the route, followed by the Norwegian-built *Suilven* in 1975 and the newly built *Isle of Lewis*, seen here at Ullapool, in 1995. High freight demand led to the cargo ro-ro *Muirneag* being introduced on charter in 2002.

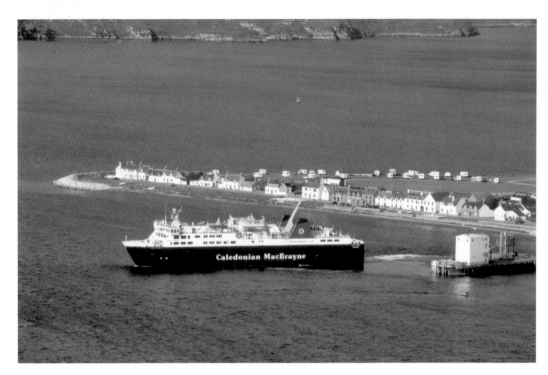

Isle of Lewis departing Ullapool.

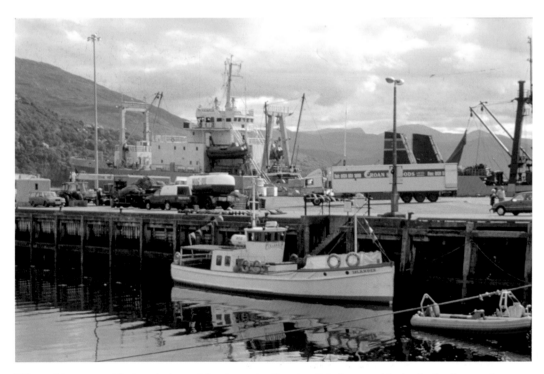

Ullapool in 1995 with the trip boat *Islander* and a Russian fish factory ship in the background.

North of Ullapool the Monday sailing from Glasgow with *Clansman* called at Lochinver, Lochnedd, Badcall and Loch Clash Pier in Lochinchard, now Kinlochbervie, and then across to Stornoway, although in the 1880s *Clansman* went from Lochinver to Stornoway via Lochmaddy and Tarbert (Harris). The cargo steamer *Lochgorm*, in 1948, also called at Scorriag, south of Ullapool on the peninsula between Little Loch Broom and Loch Broom, and at Baden-Tarbert, near Achiltibuie. In 1885, *Clydesdale* was advertised for a new service from Glasgow to Thurso (Scrabster) with calls at the island of Tanera in the Summer Isles, Loch Laxford, soon replaced by Loch Clash, and, round beyond Cape Wrath, Loch Eriboll and Tongue. In the late nineteenth century, calls were occasionally made by the Stornoway steamer at Oldney, now known as Oldany, north of Lochinver, and Glendhu beyond the Kylesku Bridge.

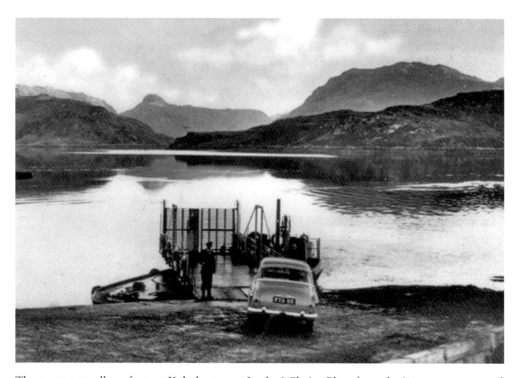

There was a small car ferry at Kylesku across Loch a' Chairn Bhan from the inter-war years until it was replaced by this bridge in 1984. *Maid of Kylesku* is seen here loading a car at Kylestrome, the southern slipway, in a postcard view from the fifties.

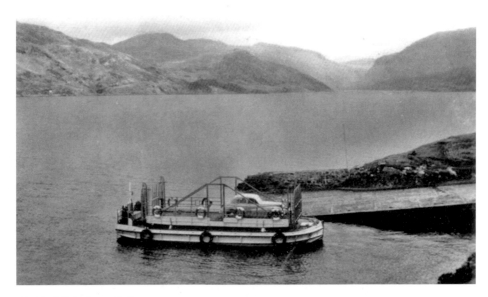

Maid of Kylesku at Kylestrome.

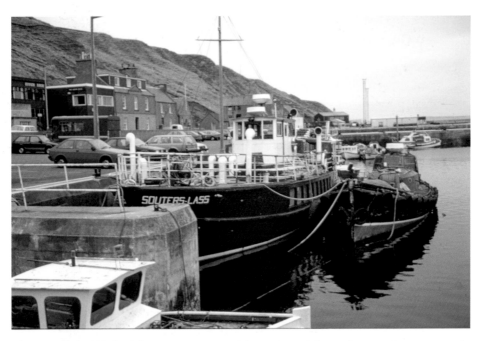

This service by *Clydesdale* was not repeated in 1886 and from then on there were only occasional trips from Stornoway to Scrabster, about five times a year, by *Claymore* or *Clansman* to transport fishermen from Stornoway to the fishing grounds of the Pentland Firth. This is the inner harbour at Scrabster in 1987 with *Souters Lass* laid up, having been recently replaced on the John O'Groats to Orkney service by *Pentland Venture* and shortly to be sold for use at Fort William.

Chapter 7

Piers on Inland Lochs

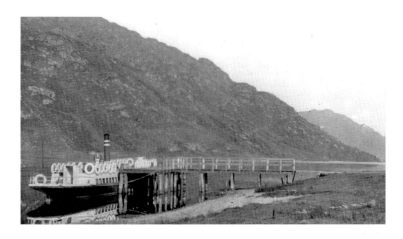

Loch Eck

The first steamer service on Loch Eck was provided by David Napier in or around 1827 with *Aglaia*, claimed to be the first ever iron-hulled steamer although only the bottom of her hull was iron and the sides were wood. She ran from Inverchapel, at the foot of the loch, where a pioneer steam carriage initially connected with steamers at Kilmun, soon replaced by a horse-drawn carriage, to the head of the loch, where there was a coach connection for Strachur on Loch Fyne, which connected with a steamer for Inveraray. The steamer *Fairy Queen*, seen here at Inverchapel, was built for the loch in 1878, and sailed until 1926.

There was an intermediate pier at Coylet, although this did not appear in the timetables.

Inset: Fairy Queen at the head of the loch, with coaches awaiting passengers for Strachur.

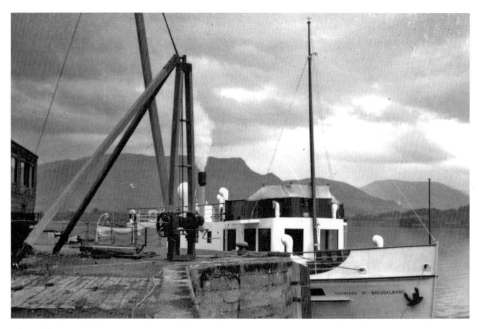

Loch Awe

The steamer service on Loch Awe ran from Loch Awe Pier at the north end of the loch to Ford at the south end. Motor vessel *Countess of Breadalbane* is seen at Loch Awe pier, probably at the time of her re-assembling there in 1936.

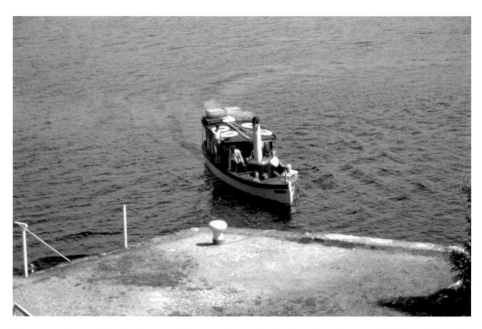

The steam launch *Lady Rowena* has run from Loch Awe pier since 1986, latterly having been renamed *Gertrude Matilda*. She is seen here arriving at Loch Awe Pier in 1989. She has mainly offered short non-landing cruises, and in recent years a ferry service to Kilchurn Castle, where an access channel and pier was built in 1996.

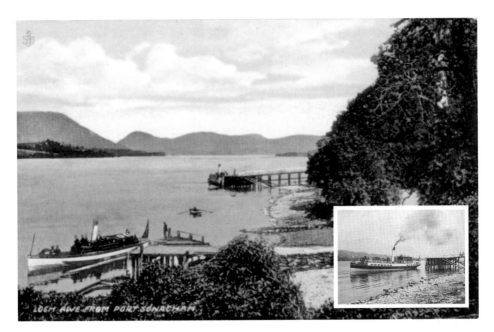

Half way down the loch is Portsonochan, seen here in a postcard view. Across from here is Taychreggan, also a call for the steamers. Calls were also made at Ardnaiseig, now a luxury hotel.

Inset: The steamer *Countess of Breadalbane* of 1882 departing Portsonochan pier, heading south to Ford.

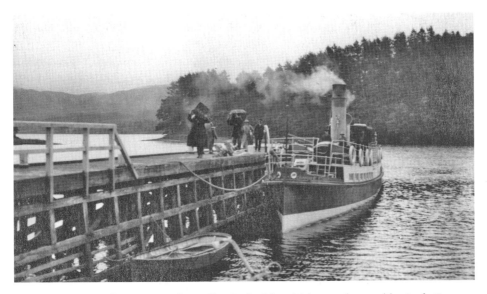

South of Portsonochan was another call at Dalavich, which was also used by *Lady Rowena* in her early years on the loch. Steamer *Countess of Breadalbane* is seen here at Ford Pier in 1923 or 1924 with the LMSR 'tartan lum' tricolour funnel. Coach connections were available from here to Ardrishaig to connect with *Columba* to and from Glasgow, giving an alternative route to Oban.

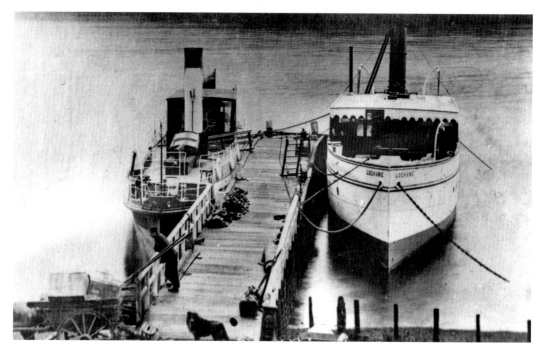

The steamers *Countess of Breadalbane* (left) and *Lochawe*, the latter owned by David MacBrayne, at Ford pier prior to the 1914 war.

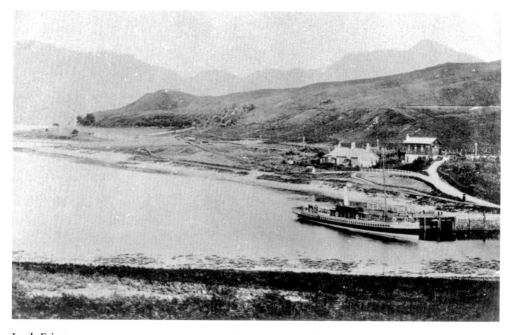

Loch Etive

The steamer service on Loch Etive ran from Achnacloich, where the pier adjoined the station, to Lochetivehead. The steamer *Ossian* is seen here at Achnacloich.

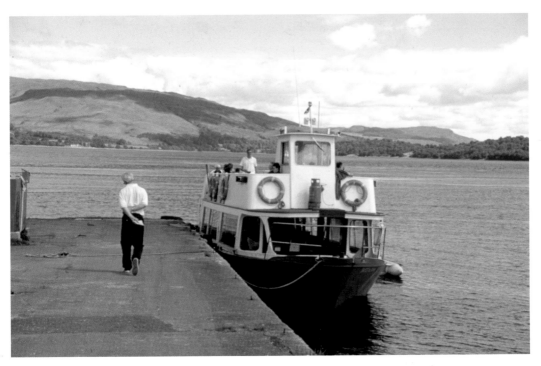

On the closure of Achnacloich station, services on the loch were run from Taynuilt, where *Anne of Etive* is seen here in 2003.

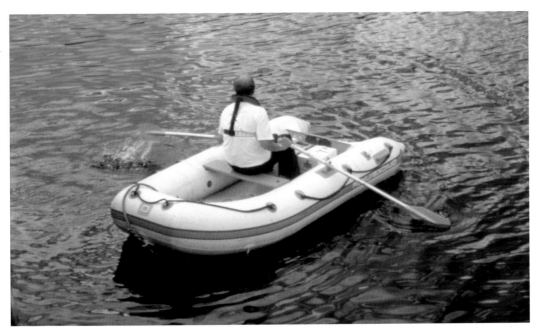

Part way up the loch there are shooting lodges and other houses with no road access. The rubber dinghy from *Anne of Etive* ferried groceries and other supplies to these locations.

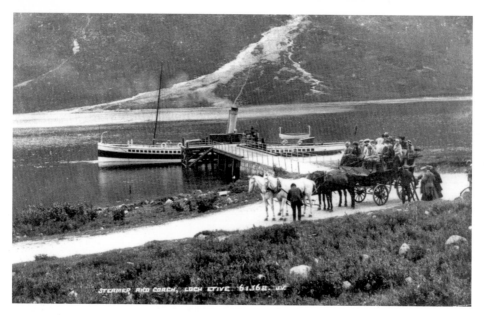

The loch steamer service terminated at Lochetivehead, where horse-drawn coaches, as seen here, provided a service to Glencoe and Ballachulish.

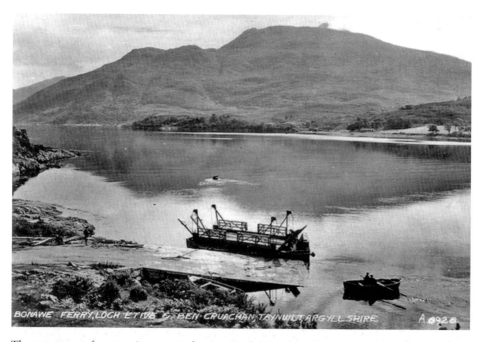

There was a car ferry service operated across Loch Etive from Bonawe quarry to Taynuilt by J. & A. Gardner. This was an old ferry service dating back at least to the eighteenth century and maintained for many years by rowing boats. The car ferries used were *Deirdre*, from 1937 until 1956, and *Dhuirnish*, from 1956 until the cessation of the service in 1967, following the closure of the railway across the Connel Bridge and the removal of the tolls there.

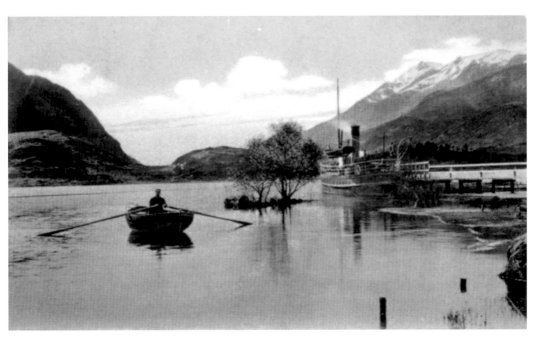

Loch Shiel
The steamer service on Loch Shiel ran south from Glenfinnan, where the steamer *Clanranald II* is seen here in a postcard view.

The pier at Glenfinnan in 1967, the final year of MacBrayne services on the loch. This pier was on the River Callop. The services operated since 1998 by the launch *Sileas* run from a jetty in the grounds of Glenfinnan House Hotel.

There were piers part-way down the loch on the east side at Dalelia, also seen here in 1967, and at Polloch, also on the eastern shore.

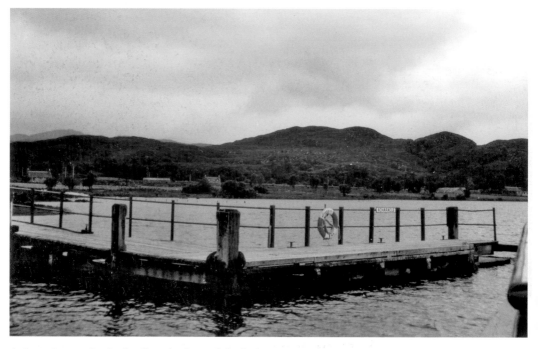

Acharacle was the final call at the foot of the loch.

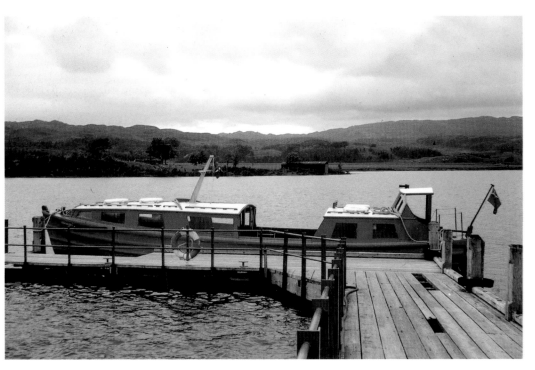

The launch *Lochailort* at Acharacle pier in 1967, her final season.

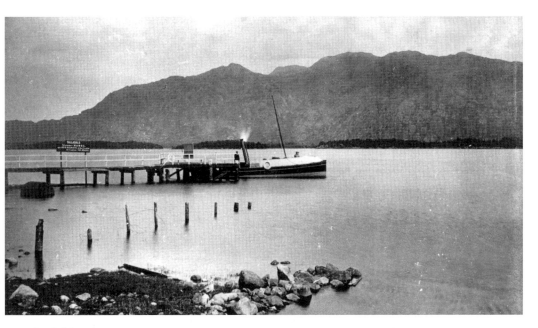

Loch Maree
The steam launch *Mabel* ran on Loch Maree from Talladale, near the Loch Maree Hotel, to Tollie Pier, near Poolewe at the western end, and Rhu Nohar, also known as Ruhda na Fhomhair, at the eastern end from 1882 until 1911.

Piers List